04.

(H)

THE ART OF

Life Lessons ∽

JEROME WITKIN

Sherry Chayat

With a Foreword by Kenneth Baker

Syracuse University Press

First Edition 1994
94 95 96 97 98 99 6 5 4 3 2 1

Unless otherwise noted, photographs were sup-
plied by the owners of the works of art. The follow-
ing photographers are acknowledged: Courtney
Frisse: plates 9, 18, 21, 24, 26, 27, fig. 10; Marc
Glassman: plate 28, fig. 21; Rita Hammond: fig. 25;
Nathaniel Kramer: fig. 27; Lee Stalsworth: plate 7;
Christian Witkin: jacket portrait of the artist; Joel-
Peter Witkin: reprint of fig. 2.

The paper used in this publication meets the mini-
mum requirements of American National Standard
for Information Sciences—Permanence of Paper for
Printed Library Materials, ANSI Z39.48-1984. ∞™

Library of Congress Cataloging-in-Publication Data

Chayat, Sherry.
 Life lessons : the art of Jerome Witkin / Sherry
Chayat ; with a foreword by Kenneth Baker.
 p. cm.
 Includes bibliographical references.
 ISBN 0-8156-2617-7. — ISBN 0-8156-0279-0 (pbk.)
 —ISBN 0-8156-2645-2 (ltd. ed.)
 1. Witkin, Jerome—Criticism and interpreta-
tion. 2. Figurative painting, American. 3. Narra-
tive painting, American. 4. History in art.
 I. Witkin, Jerome. II. Title.
ND237. W777C47 1994
759.13—dc20 93-38713

Printed in Hong Kong
by Everbest Printing Company, Ltd.

∾ *for* JAMES & BARBARA PALMER,

whose enthusiasm and support
were crucial to the project;
and for my mother,

SYLVIA CHAYAT

Sherry Chayat was born in Brooklyn, New York, and educated at Vassar College, where she majored in creative writing and was inspired by Linda Nochlin, who became an important mentor. Her first job after graduation was at Perls Galleries on Madison Avenue, which she left to continue painting, first at the New York Studio School and then in the South of France. She began writing on art in 1969, as an editorial associate at *ART-news*. Her articles and reviews have appeared in many journals since then. She is the art critic for the *Syracuse Herald American* and has won several awards and grants. She teaches at University College, Syracuse University.

✑ CONTENTS

❧ COLORPLATES & FIGURES

❧ FOREWORD

THAT VISUAL ART mirrors its own time is a common assumption. The question, especially in the modern era, is how we recognize this.

Answers are more available in the paintings of Jerome Witkin than in most contemporary art, painfully available at times. Staging dramas whose reference is at once historical, autobiographical, and literal (based on live models in the studio), he brings under the spotlight of consciousness anxieties, temptations and calamities we prefer to keep in shadow by evasion and denial. Too much contemporary art, by its esoteric indirectness, is a tacit conspirator in our secret project of staying numb to what we know and feel and to our helplessness in face of it.

Witkin fulfills painting's little-exploited potential for bearing witness, not to events themselves, but to their report upon his own memory, sensibility, and apprehension of the future. In this endeavor, he bravely treats himself as a representative being, one who takes his own fears and revulsions as an index of what others too must feel, whether they admit to it or not.

This assumption of moral common ground is the generous premise we miss in so much contemporary art that pretends to moral animus. We miss it too in photography, a medium surveillant of the terrain of human action whose sensitivity is merely technical until channeled and focused aright by the person who wields the camera. The moral neutrality—the so-called objectivity—of the camera is the nightmare from which Witkin's art tries to shock us awake. (The camera work of his brother, Joel-Peter, works a similar effect by other means.) The dramas Witkin stages on canvas touch some of the most inflammatory events and issues of our age: the Holocaust, the horror of nuclear weapons, the downhome temptations of zealotry and violence.

The aesthetics of modern painting do not readily accommodate Witkin's theme: the inescapability of moral pressure, of quandaries that force us to choose values and take sides, even if only in our heads. "One cannot live without some interpretation of life," as José Ortega y Gasset writes. "This interpretation

is, at the same time, a justification. Whether I like it or not, I must justify to myself every one of my acts. Human life is, then, at once crime, criminal and judge. . . . For the very reason that life is, at root, always disorientation, perplexity, not knowing what to do, it is also an attempt to orient itself, to know what things are and what man is in the midst of them."

To bring this theme to life, Witkin has had to resuscitate the tradition of European narrative painting presumed dead by twentieth-century modernism, the tradition that extends from the Renaissance through Caravaggio, Rembrandt, Goya, Courbet, and Van Gogh.

In contrast to the painting of social realists of the Depression era, who made their own brave effort to reanimate pictorial narrative, Witkin's art reflects not just his awareness of history but also his cognizance of what history has done to painting. It is not just the drama of Witkin's paintings that makes them convincing, nor their sturdy foundation in observational drawing, but the pleasure and freedom of paint-handling that they display. More than any other painter working today, except perhaps Lucian Freud, Witkin recapitulates, at the level of fine detail, the emergence from traditional structures of modern painting's distinct expressive freedom.

Among the things about Witkin's art that need explaining is why, given his accomplishment, his is not a household name, even in the art world.

We have Sherry Chayat to thank for the explanation of this and other surprises that Witkin's career offers. Her study has the virtues of descriptive vividness and accuracy. But even more important, she does not interpose herself between us and the art. She deploys the tools and biographical materials of interpretation without crowding them between us and Witkin's pictures. And she lets the painter's voice sound, it seems, almost as often as her own. Without undue ardor and without caricature, she manages to evoke the sense experienced by viewers of Witkin's paintings that they fulfill a life's destiny, something we secretly hope to feel in the presence of an artist's work but seldom do.

There is little optimism in Witkin's painting. It holds out no hope of a better future, only the hope of more exemplary work to follow. Yet Witkin's art will always be heartening to anyone who believes that contemporary art ought to be a moral force, not just a decorative luxury or a didactic flail. He proves that human content in art today, when skillfully realized and genuinely felt, needs neither apology nor translation.

September 1993

Kenneth Baker
Art Critic
San Francisco Chronicle

❧ ACKNOWLEDGMENTS

I wish to thank Jerome Witkin for his openhearted cooperation throughout all stages of this project, and for inspiring countless viewers through his work. I am very grateful to James and Barbara Palmer for their generous support and their perceptive reading of the manuscript. The comments and suggestions of David Tatham, professor of fine arts at Syracuse University, and my sister, Juliet Chayat, were immensely helpful. My mother, Sylvia Chayat, provided invaluable technical assistance. My gratitude to my husband, Andy Hassinger, and son, Jesse Hassinger, for their unwavering encouragement, patience, and love, knows no bounds.

∾ LIST OF DONORS

CONTRIBUTORS

James R. and Barbara R. Palmer
Richard A. Florsheim Art Fund
William Fleming Educational Fund
College of Visual and Performing
 Arts, School of Art and Design,
 Syracuse University.

PATRONS

Anne Merck-Abeles
Sigmund Abeles
Sara Jane Berman
Leslie Collins
Alejandro Garcia
Kay Kimpton
Paul Matthews
Serge Michaels
Rachael Sadinsky
Joel-Peter Witkin
Mary L. Witkin

Life Lessons

THE ART OF JEROME WITKIN

I ❧ A PAINTER'S CROSSING

THE DOOR to Jerome Witkin's loft leads first to a small antechamber that resembles a life-size Joseph Cornell box. As do many artists, especially those with a strong respect for magic, Witkin hoards what others throw away. Childhood photographs and comic books, miniature ladders, old shoes, capes and hats, magazine clippings and toys: in Witkin's world, they bristle with significance—talismans to be used and reused in the vast mythology of his paintings.

"It's me—and I'm petrified with Fear. . . . Of myself!" reads the cover of an old Captain America comic. A Jewish National Fund certificate bears witness to a tree planted in Jerusalem in memory of the artist's father. Over the doorway are the Hebrew letters for *Tikkun,* and the translation, "to heal; repair, and transform the world."

Scrawled graffiti-style on one wall, barely legible beneath the layers of clippings, photographs, and mementos, is the inscription "The Jerome Witkin Museum of Props and Memories." On an-other leans a large metal sign. The letters, in running script, spell out *Painter's Crossing,* the title in part of a break-through work of 1976–1978.

The sign seems an apt metaphor for Witkin at mid-career. It hints at his need to wrest meaning from his own time while exploring historical moments. It points to the dialogues in his paintings between Old and Modern Masters, social realists and abstract expressionists. It suggests as well the convergence in his work of high art and entertainment.

Despite his stylistic virtuosity, form is the handmaiden of content for Witkin. He often subjugates his considerable technical facility to the gut-wrenching harshness of his subject matter, intentionally letting his brushwork turn clumsy, his palette noxious. At other times he consciously sacrifices good taste to theatricality. Unlike many post-modern figurative artists, in whose work obfuscation seems intentional, Witkin has a message, and he wants it to be received; more than that, he wants to be an agent of transformation. Calling

himself "a cornball humanist," he creates for his newsstand vendor as much as for his gallery.

The words *Painter's Crossing* can also be seen as a symbol of the artist's spiritual journey. When Witkin enters his studio, he leaps into the dark realm of political repression and the Holocaust, the private wars of domesticity, the collision of recurrent nightmares and the evening news.

The studio itself is an *L*-shaped loft on the third floor of the Delavan Center, an old warehouse in Syracuse that was transformed by the owner, Bill Delavan, into a warren of artists' work spaces. Witkin's studio is an ever-changing theater set in which the painter has his models enact frequently traumatic dramas that draw upon incidents in which the historical and the personal converge, become inextricable. The walls are covered from floor to twelve-and-one-half-foot-high ceiling with sketches, news clippings, drawings, quotations, and preliminary paintings, all related to the major work of the moment, whether it is the painter's interpretation of a beating station in Nazi Germany or his vision of Vincent Van Gogh's final confrontation with madness.

"In the privacy of the studio, the artist is saying, 'I'm here, trying to make some breakthrough, trying for some enlightenment, trying to push the future through into the present,'" Witkin says. "I agree with Redon: revelation is the key.

"How do you face the void? How do you tolerate it? The artist must be willing to march into hell and back again." Quoting freely from Linus Pauling, he says, "I don't believe in God, but I believe in the diminishing of pain. And painting is a healing force. We're stuck here; we have to do something about the here we're stuck in.

"The arrival of a painting has an importance beyond my own fantasies," he adds. "I make it better by adding doubt, not by being a fanatic. If the artist were certain, he wouldn't make art, because he wouldn't be searching." Still, Witkin is intrigued by what he calls "knowing something beyond yourself."

When the work is going well, it is as if the painter, with his personal concerns and concepts, has disappeared. The painting moves through him; he is out of the way. "I look at a finished painting and I feel I'm an angel," he says. "Did I do this? Not quite. It was the force of two, not one—like making love. Who's making the art? The art makes the artist."

Another crossing—of the border from the single canvas to the all-engulfing sequential experience—has preoccupied Witkin since the sixties. His first polyptych was a cruciform painting, done in 1962, depicting figures seated around a table; two years later, he painted a large four-paneled autobiographical work, a symbol-laden forerunner of the 1984–1985 *Division Street.* Even many of his single canvases, such as *Roberta Braen: The Art Teacher* of 1982–1983 and *This House on Fire* of 1983, are split vertically to suggest the intersection of two levels of consciousness and the passage of time.

The large-scale sequential format that Witkin chooses so frequently has a heroic grandeur, yet it avoids the inflated

idealism of epic painting, returning us again and again to the reality of the everyday world. And unlike the altarpieces of Matthias Grünewald or the monumental triptychs of Max Beckmann, Witkin's polyptychs depict the passage of time, not different views of the same moment. With the movement of the eye from one panel to the next, it is as if we are activating a projector. Underlying his use of sequential frames is the artist's fascination with the cinema and comic books, as well as with Japanese scrolls. "I was first introduced to Oriental art on a visit to Boston at the age of fifteen," he recalls, "and I was very taken with a scroll at the Museum of Fine Arts called *The Burning of Sanju Palace.* What struck me was the possibility of moving through time visually."

Witkin is at a biological crossing as well. Having turned fifty in 1989, he is acutely aware of the passing of time. The night-blooming cereus, with its few hours of exquisite beauty, has become a private metaphor. His several close calls with death—meconium aspiration at birth, a near-drowning as a teenager, and more than one accident in which he walked away unscathed from a totaled car—may have contributed to his preoccupation with grand themes. "After so many near-misses, you feel you're here to *do* something," Witkin says. "The other side of that is feeling not quite real, as though you're being dangled into life like a teabag."

His visual narratives, like those of Caravaggio, La Tour, Delacroix, and Rembrandt, revolve around the major dilemmas of human life: love, evil, ob-

session, and, of course, death. But Witkin's vantage point is thoroughly late–twentieth century. Thus, the Devil manifests himself in the body of a tailor sewing Nazi uniforms; the protagonist of *A Jesus for Our Time* is a firebrand evangelist who ends up soused in his hotel room; Death is an usher in a German theater during the Holocaust; Robert Oppenheimer comes back to assuage his guilt before a priest whose body is horribly burned, whose confessional box is littered with the detritus of Hiroshima.

"In polite society, we're told not to talk about politics, sex, and religion," Witkin says. "That's all we really want to talk about. I don't know how to make polite paintings."

Despite the weightiness of his subject matter, there is nothing ponderous about these works. If Witkin is a moralist, he is one in the tradition of the Fool. An inveterate teller of jokes—most the sort that make his listeners groan—he sees a close parallel between art and street humor. Along with his deep-seated convictions about the responsibility of being human is his equally strong sense of what he calls "the hokey edge to being heroic." Narrative painting is, after all, a story leading to a punch line. And in addition to believing in the necessity for comic relief—the saving grace of his own dark childhood—he is keenly aware of the humor of his own dilemma. Witkin, kin of wit—his father, on his infrequent visits, would attempt to lighten an unbearable family situation by telling joke after corny joke—probes the layers of allusions and offers up visual puns.

3

"Why do I believe I have the moxie to make such a presentation?" he wonders. Like the comedian or the storyteller, the narrative painter "sets something up and resolves it in unexpected ways. We even set up crises just to see how we'll get through them. That's what jokes are. The unexpected is the key element in jazz, film, the stand-up comedian's stories, art—brush mark by brush mark, I'm playing with the power of the hot stroke, the next move." For Witkin, it is not only compelling social issues, not only the dark passages of the spirit, but what is amusing that constitutes the muse.

Finally, and from the beginning, there is the involuntary crossing of identities that so often marks identical twins. The painter's brother is the well-known photographer Joel-Peter Witkin. Running throughout Jerome's work as a pictorial device is the double image, either through repetition of the same figure, as in *Painter's Crossing: To the Passions of Rembrandt,* or through the reflected image in windows and mirrors, as in *Killjoy: To the Passions of Käthe Kollwitz, Subway: A Marriage, A Jesus for Our Time,* and many other paintings.

Although Jerome and Joel have established their careers quite apart from each other, now and then they have shown together. In both brothers' work, there is a glint of the macabre, a tweaking of reality. Each seems drawn simultaneously toward the mystical and the iconoclastic; and each seems imbued with the feeling that the body double is at once remarkable and shameful.

"Being a twin, a mirror image, is in some fundamental sense being a freak," Jerome says. "In some cultures twins were considered divine; in others, they were destroyed."

What separates their work is a radically different sensibility. Joel's photographs exude a complicity with evil; Jerome's paintings exorcise the demonic. In his fascination with the freakish, the photographer frequently seems to exploit his subjects' deformities; using imagery of bondage and confinement, he heightens their isolation from society. For the painter, however, art is redemptive. Even in his *Unseen and Unheard (In Memory of All Victims of Torture),* which is as harrowing a viewing experience as any of his brother's photographs, the artist's compassion and his implicit exhortation to speak out against this crime are paramount. For him, twinship has heightened his sense of empathy. "Perhaps because of being an identical twin, I've always felt the possibility of transference," he says. "I can easily become another, feel another's pain."

The painters Witkin most admires are those whose work expresses a profundity and compassion born of personal struggle and, often as not, delayed recognition—artists like Grünewald, Rembrandt, Breughel, Goya, Van Gogh, Kollwitz, Guston, Kitaj, Lucian Freud. "Grünewald is my greatest hero and mentor," he affirms. "He's so expressive, so willing to be clumsy and honest; and his work is for the betterment of man's pain."

Just as Witkin is drawn to heroic feats, he is suspicious of the limelight gained too quickly, too easily; of young artists whose paintings command five-figure

prices, who are courted as stars of the entertainment world, but "who don't even cast shadows." When, in 1976, Witkin began working on *Painter's Crossing: To the Passions of Rembrandt* (plate 2), he envisioned it as an invasion of the painter's private world: "Like kicking in a door with a search warrant and seeing how a singular person exists," he wrote in his journal. Later that year, studying Rembrandt's 1669 *Self-Portrait* at the Maurithaus in The Hague, he wrote, "It's so keen and accurate and controlled. His shadows are so sad and melancholic. How he offers himself up to be observed."

Painter's Crossing: To the Passions of Rembrandt throbs with the tension between the painter's struggle to create works of authenticity and his dreams of worldly acclaim, an acclaim that would reach beyond the grave. Hunched over his studio table, Rembrandt-Witkin receives a visitation, not from an angel but from a muse, bearing glad tidings of fame (conveyed by the letters on her shirt). She holds a neon star that floods half the painting with its rosy promise.

The painting is a cautionary tale, showing the artist pulled one way by the allure of quick success through art à la mode and the other by his allegiance to his own voice, to the creation of something powerful enough to summon up the magic of the real.

In his review of Svetlana Alpers' *Rembrandt's Enterprise: The Studio and the Market* (University of Chicago, 1988), George Steiner wrote, "Somewhere at the heart of Rembrandt's enterprise seems to lie the dread realization that

time is on the side of the brushstroke, and not on that of the hand: that the supreme artist—and Rembrandt knew himself to be one—is a formidable creator but his aging and his ineluctable death make of such creation a sort of blasphemy."[1]

"Like Rembrandt, Jerome Witkin at the end of his third decade is tempted by the glory of Fame," wrote Richard Porter, registrar at the Palmer Museum of Art at Pennsylvania State University, in the catalogue for a traveling exhibition that originated there in 1983. "But how can an artist so independent and contemptuous of popularity achieve fame during his lifetime on his own terms? Often it is a question of longevity, of remaining true to sound principles and creating works of real quality until critics and public come to an appreciation of those works, an appreciation that the lesser artist might compromise himself to achieve at an earlier age."

In his journal Witkin mused, "I am what I am and must use the positive of it all. I love subtle mysteries in reality—shadows, grey dishwater, dust, the personal and moving and touching objects in light. . . . I must vibrate in unison with my vision. The *quiet,* that "silence" of the *present* scene will alone define me and what I've tasted of life. Let others use words—I'll embrace that silence of quiet, melancholic scenes. . . . Lost, poor, leftover, abandoned, back-room, closet—these are words that begin and contain my vision."

The muse who materializes over the figure lost in reverie at his studio table senses, perhaps, a vulnerable moment.

Appearing through the window over a building whose sign reads "Tattoo," encased in a diamond shape (echoes, perhaps, of the Beatles' then-popular song "Lucy in the Sky with Diamonds"), she seems more a symbol of temptation than of inspiration.

Witkin's use of the medieval and Renaissance device of continuous narration, in which the same figure appears in different poses and different times, indicates his fascination with portraying temporal sequences in two-dimensional space; it also points to his underlying awareness of being a twin, a mirror image of a very different Other.

The standing figure before the easel is bathed in a harsh blue-white light—a light of studio fixtures, rather than the rosy spotlight of instant celebrity. Brush in one hand, wiping cloth in the other, he regards his painting intently. Caught in the act, he seems to know there is no short cut to artistic integrity; work, and work alone, can save him. He must be his own muse. On his canvas, reflected in the window behind him, we can make out a group of figures clustered at one end of a table, all suffused in the intense golden light we associate with Rembrandt's middle period.

Rembrandt, during the 1640s, 1650s, and 1660s—despite a private life plagued by domestic difficulties and economic crises—was creating such masterpieces as *Christ at Emmaus, The Night Watch, Bathsheba, The Jewish Bride,* and *The Return of the Prodigal Son.* Uncompromising in his aesthetic ideals, he saw himself as the historical painter of his time, as the leader of a new school devoted to the production of large-scale works with moral underpinnings. Witkin's sense of kinship with Rembrandt readily eclipses the span of three centuries that separates the two artists.

II ❧ BROOKLYN AND BEYOND

THE GREEN that drenches the first two panels of the 1984–1985 triptych *Division Street* (plate 13), Witkin's autobiographical tale of domestic trauma, is not a healing green; it is not a green found anywhere in nature. Its lurid hue is one that crackles with electricity. This is a green of traffic lights (GO!) and jealousy (MINE!) and brutal ending: (ZAP!). As do so many of Witkin's paintings, this one encourages readings between the lines. The codes are to be found not only in the taut brow and the hurled paint, but within our own lives, summoned up by what we see—no closed system here. The action moves sequentially from panel to panel; the set is open-ended. We are invited in to be silent witnesses, along with the small child cowering in his chair. The dishes smash against the wall, the door slams, and the entrails of that night's spaghetti dinner dribble down the pale green paint.

Witkin's sensitivity to the telling gesture is matched by his ability to convey it with the telling mark. Never static illustration, his narrative is driven by compulsive forces, both psychological and formal. In the first panel, for example, amidst the abstract calligraphic swirls of steam rising from the plates of spaghetti, we can see the mother's hand already in the preliminary position of a discus thrower, pasta sliding off toward the table. From the curve of that plate we follow those of her breasts and the father's shoulder and head; we are stopped by another circle, another equally powerful gesture: the father putting on his hat. In the days when men wore hats, that would have been a decisive moment.

The boy's head is turned in profile, echoing his father's; his face is hidden by a furled comic book, much as his father's is by his hat. Each reveals one ear, a prophetic symbol of the cacophony to come. In the next panel, we see the boy full-face, cringing, one large, staring eye bearing mute testimony as around him sail the platters, the splattered food. Head down, pummeled by the whirlwind of hurled rage, the father thrusts toward the black hallway beyond, his suitcase ripping from his grasp.

Witkin's application of paint in *Division Street* is as savage as the action it

describes. Murky layers create a dense and pregnant space in the first panel; in the second, the paint all but flies across the canvas. Positioned against uncompromisingly linear elements, the moving target and the fusillade of plates seem even more cataclysmic.

In the third panel, the green has subsided, the boy has disappeared, the family portrait on the wall has gone blank. The blue notes of the first panel are now the primary tones, filling the closed door and the apron. The smoldering tension in the mother's face, illumined by the harsh white light, is heightened by the riveting yellow vertical of the broomstick clenched in her fist and the turbulent folds of her apron. Broken crockery covers the boy's comic, abandoned in his flight.

The curving diagonal that moves from lower left to upper right in the first panel is repeated in the second but arcs into a circular movement that reaches a crescendo in the plate breaking above the boy's head. The green curve from his chair to the wall behind him becomes the final balancing diagonal of light in the third panel, completing the momentum set up by the opposing angle of the first panel. This strongly directional illumination, which brings Caravaggio to mind, infuses the relative calm of the third canvas, with its quiet blue and white ("Mary's colors," T. S. Eliot called them, and the artist's mother is indeed named Mary), with a religious flavor. Flooded with a transforming light, the mother goes about her mopping up, her face a complicated play of spent fury and new-formed resolve.

Division Street hovers teasingly on the border between the grandiose and the mundane, the universal and the specific, the enigmatic and the familiar. Its shifting blend of form and chaos, fact and fantasy mirrors the function of memory—and is accutely descriptive of Witkin's childhood.

The section of Greenpoint, Brooklyn, where Jerome Paul and Joel-Peter Witkin were born to Max and Mary Witkin on September 13, 1939, was almost entirely working-class Italian Catholic. Mary Witkin's father, Giuseppi Pellegrino, had left Naples to seek a better life in the United States. He began by scavenging bottles from the streets, washing them, and selling them. In true immigrant success-story fashion, he soon had a thriving business, maintained a large house and chauffeur, and owned many buildings on Division Street. Mary and her sister grew up in an atmosphere of comfort and culture, of music lessons and poetry. Then came the Depression. The Pellegrinos' financial disaster was total and irreparable. The music lessons stopped; Mary went to work. Her dreams of artistic fulfillment became a legacy for her children.

Her oldest child, Sara, was three-and-one-half when Mrs. Witkin gave birth to triplets: Jerome, Joel, and a still-born girl. Joel was born first; then Jerome, who spent the next three days in intensive care because he had aspirated meconium. It set the first of many stages of competition between the boys. "Joey got both tits," Witkin says. "The nurse told her she was getting both babies, one after the other. Maybe she didn't know."

8

The twins were three-and-one-half when the scene depicted in *Division Street* occurred. In Jerome's memory he was the only child present during that particularly stormy argument, at the height of which Max Witkin left and did not reappear for six years.

Max Witkin was one of six children. His mother, Sarah Berlitz, had fled Poland at the turn of the century, during one of the great waves of emigration sparked by the pogroms against the Jews. She died before Jerome was born. Her husband, Meyer Witkin, had come from Lithuania. "I only saw my grandfather once," Jerome says. "I saw him walking down the street; he avoided me. My father's family only lived a few blocks away, but there was no contact with them."

The children were raised by two powerful women. Their maternal grandmother, Maria Antonia Pellegrino, had an apartment in the same building. "She took care of us while my mother worked at the DDT plant on Division Street," Witkin recalls. "My fondest memories of childhood are of her. She used to get me rolls of shelf paper from the bakery down the block. I spent a lot of time drawing on those as a kid—before and after school, I was always drawing little figures on those huge sheets of paper. I saw images as a way to read, to understand."

Grandmother Pellegrino was an avid afficionado of opera—every kind of opera, from Verdi to the soaps. Perpetual plots and counterplots, whether set to music or not, thickened the atmosphere, and not just on the radio. Intricate family feuds wound on and on like endless skeins of yarn. Witkin remembers every

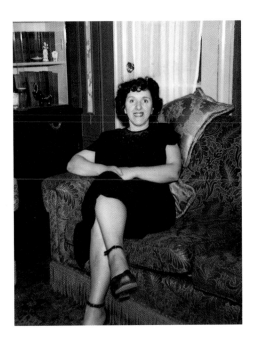

Fig. 1. Mary Witkin at 460 Graham Avenue, Brooklyn, 1950

word being greeted with suspicion, mined for hidden significance. And outside the family more tales were spun; life in Greenpoint seemed to be conducted mainly on the stoops, listening to stories of exploits and remorse, of short-lived idylls and long-term dues.

Mary Witkin loved high drama, too. She took her children to plays and movies, vaudeville and prizefights. At home, she was her family's producer. "We were her performers," Witkin reflects. "She was the great puppeteer. We believed her version of our lives." With an enthusiasm for intrigue and exaggeration seemingly bred in the bone, the Witkin household was a collection of people acting out their lives, toying with the shifting boundary between illusion and reality. Crises were so interspersed with comic scenes that they seemed interchangeable; one had simply to flip the dial to another station.

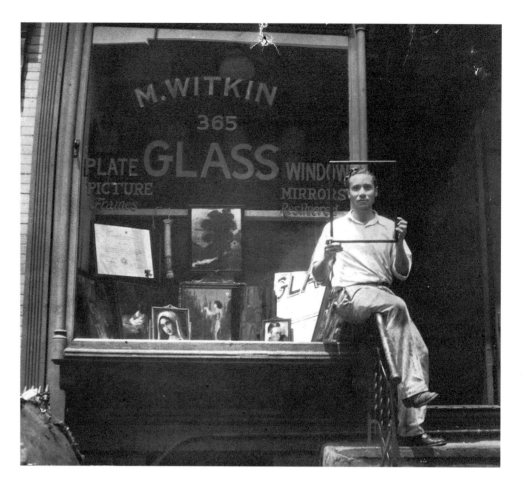

Looking back on those days, Mrs. Witkin says, "I always felt my children should learn. there was no television to take up our time; we listened to the radio, we sat around and talked, we read, and always, Jerome would be drawing. He would draw my mother in her chair, his sister, me—he always had a pencil and a piece of paper, ready to draw anybody who was in the room."

She remembers the first drawings Jerome showed her. "I was amazed. I thought he had traced them. I asked him, 'Did you copy these?' He said he hadn't, but I couldn't believe it. I said, 'Sit down, draw something for me.' And he did. I was so amazed! He was very popular with his schoolmates because of his ability to draw. Batman was the big cartoon character back then. Jerome would do pictures of Batman with chalk on the street, and all the kids would say, 'Oh, look, how good it is!' I'd watch from our fourth-floor window overlooking the street. The kids would tell him which cartoon characters to draw."

Joel-Peter's talent was not in evidence during those early years. "Joey was a sleeper," Mrs. Witkin says. "He never went in for anything artistic, never drew anything convincing. His ability showed up later. He always loved cameras. I

worked for awhile for a company that made lights for photography studios, and my employer was giving a class in photography. I asked Joey if he'd like to sit in, and that's when he got his first exposure."

The twins were nine when their father reentered their lives. "He came in, a giant, bearish man, and turned to me to say hello," Witkin remembers. "I backed up and ran. He never forgot that." Despite an unpropitious beginning, Max Witkin began a pattern of regular weekly or biweekly visits. It was always painfully awkward. "He'd tell corny, trashy jokes," the artist recalls, "but the artfulness of his delivery seemed more important than the content. I guess the jokes were his way of getting through the two or three hours of those visits. He was proud of my artwork—he called me 'Michelangelo Witkin'—and later he forced me to do a painting of him surrounded by various people who were famous at the time."

Max Witkin, a glazier, was highly regarded by his colleagues in the trade. One of his most impressive commissions was a mirrored canopy over the pool at the St. George Hotel in Brooklyn. At the age of thirteen, Jerome went to that pool with some friends. "I didn't know how to swim, but on a dare, I jumped off the high board. I kept going down; I couldn't stay up. The third time, I remember feeling so sleepy and comfortable, so embryonic." Under the impassive eye of his father's glass canopy, Jerome yielded to the pool's depths. "I knew I was dying. I remember realizing my mother would be very upset, but being too comfortable to struggle any-

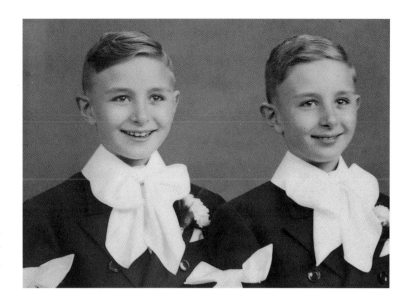

Fig. 3. Jerry and Joey, age nine, on the occasion of their first communion, St. Cecilia's Church, Brooklyn

more." Just in time, someone pulled the boy to safety.

Max Witkin married again, but that, too, was a failure. Still in his forties, he attempted suicide by jumping from a roof; again, he was unsuccessful: a tree broke his fall. In the ensuing years, his drinking increased, his career disintegrated, and his life became that of a derelict. At one point he landed in Bellevue Hospital, where he was placed in the same cell as George Lincoln Rockwell, the American Nazi—with whom, he later reported, he got on famously.

Plagued by inner demons, relegated to the role of the fool during his brief and awkward visits, Max had little influence on his children's upbringing. Sara, Joel, and Jerome were raised in an emphatically Catholic milieu. Much later, in very different ways, they would explore their Jewish heritage: Joel, through his search for and discovery of Max's sole surviving relative, his brother Julius; Sara through marriage; and Jerome, through his

11

Fig. 4. Sara and the twins at McCarren Park, Greenpoint, Brooklyn

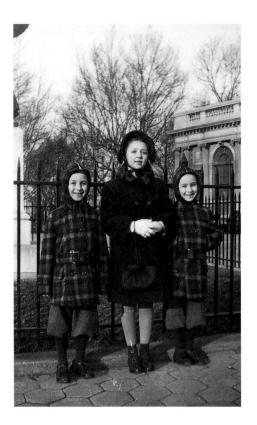

paper flowers. We had to do everything by rote, mixing colors and copying the nuns' pictures." Everyone was greatly impressed with Witkin's talent. Early on, he began signing all his work "FHGG"— "For the Honor and Glory of God."

"I've always been afraid of claiming these abilities for myself," he says. "I've always felt something is doing it through me, for me."

Those early art classes were filled with frustrating restrictions. "Once the nun asked us to do a painting of a church for a Christmas card. I found one I liked, a small chapel, but she wouldn't let me do it, because it wasn't a Catholic church. I couldn't afford to buy paint; that was another humiliation. Then there was a contest, and I won. I stole some extra lottery tickets, and I won a paint box. I felt so guilty I dumped the box in the cellar. I still have the paper bag it came in." St. Dominick's reinforced Witkin's sense of himself as an outsider. "I never wanted to conform. I figured, I'm different, I might as well stay different, even if I am humiliated by it."

A similar message was conveyed during one of his first visits to the Metropolitan Museum of Art. "I was around eight years old. My mother left me to wander for a half hour or so. I remember looking at some enormous rugs on the wall, and then I saw a person coming toward me holding a walking stick. Before I could get away, he pinned me down with his stick and said, 'Dirty boys like you shouldn't be in museums.'" Now a painting and a drawing by Witkin are in the Metropolitan's collection.

paintings about the Holocaust. But in the meantime, their lives were circumscribed by the nuns who taught at St. Cecilia's, which was run by the order of Christian Brothers. The family moved to Queens when the twins were eleven, and they continued their education with the Notre Dame sisters at Our Lady of the Miraculous Medal.

Witkin's first art teachers were nuns. When he was seven, his mother had begun sending him to Saturday art classes at St. Dominick's Art School, a long bus ride away in the Bushwick section of Brooklyn. "I was always early, and I would wait at the door, freezing. There were two nuns and about twelve kids. They had an art shop with baskets and

In 1953, at the age of fourteen, he was accepted by the High School of Music and Art in Manhattan. It was a turning point. The trip from Queens, by bus and three subway trains, took one-and-one-half hours, and buying art supplies continued to be a problem, but high school provided the first glimpse of what life on the outside was like. "I felt wonderfully privileged. I was so impressed with the change in my life from the smothering Catholic environment to the liberal atmosphere of worldly Manhattan. Music and Art was about 15 percent black and Hispanic; the rest of the students were Jewish. The kids there seemed to know all the answers."

Witkin found himself surrounded by talented and inspiring students and teachers. Although he felt the teachers in the art department weren't tough enough—"everything seemed so easy, so cozy after the rigors of Catholic school"—he was grateful to them for leading him to important artists' shows and studios. The chance to meet the key artists of the time seemed more significant by far than the classroom education at the High School of Music and Art. The New York School was in full bloom; Witkin and his friends made frequent visits to the Tenth Street studios, the museums, the galleries, the cafes.

"I remember the smell of paint in Jack Levine's studio, the political content of his work, his radio tuned to Edward R. Murrow, and I was knocked out by his show at the Whitney. I'd go to shows with Willem de Kooning, sit at a table in a Jewish deli with Mark Rothko, eat spaghetti at the Cedar Bar with Franz Kline. I remember Alex Katz's first show at Tanager Gallery, and Tom Wesselmann's, too."

When he was fifteen, Witkin entered *Seventeen* Magazine's contest for "It's All Yours," an issue devoted to young people's writing and artwork. He won first prize for his illustration of a short story called "A Season Between." At the reception for the prizewinning teens, held at the Waldorf-Astoria, Witkin overheard Raphael Soyer say to a friend, "This guy draws like a forty-year-old." He was pointing to Witkin's illustration. *Seventeen*'s art director, Arthur Kane, was so taken with the drawing that he recommended Witkin for a full scholarship to Skowhegan School of Painting and Sculpture, and in the summer of 1955 Witkin found himself in the company of Ben Shahn, Isabel Bishop, George Grosz, Jack Levine, and other important painters of the era. Jerome's roommate was one of Shahn's sons, and the elder Shahn took them both under his wing. Witkin also spent many hours with Grosz. "He was a rickety old man then, and it was my job to take him from his house to his studio." While walking slowly along the wooded paths, Grosz would speak to the young artist about the early days of Dadaism in Berlin, his court-martial and near-execution during World War I, the harassment and censorship of his work by the Nazis, his fortuitous escape to the United States. "I was being blasted by all these heavy people," Witkin recalls. That summer at Skowhegan was also the first time the youth had ever confronted a

nude model. "At fifteen, that got me very excited. She just came in and took all her clothes off. I was so taken with the incredible beauty of her body."

The painters he met at Skowhegan were part of a group of social realists whose early politicization had been sparked by the suffering during the Depression and the Holocaust; now, in the McCarthy era, they found themselves an ostracized minority. In part because social realism had come to be associated with leftist political views, figurative work was being eclipsed by a new kind of abstract painting that, in its function as a symbol of personal freedom, could be used by politicians as an effective weapon in the cold war.

In a 1973 essay Max Kozloff wrote, "Never for one moment did American art become a conscious mouthpiece for any agency as was, say, the Voice of America. But it did lend itself to be treated as a form of benevolent propaganda for foreign intelligentsia. Many critics, including this one, had a significant hand in that treatment. How fresh in memory even now is the belief that American art is the sole trustee of the avant-garde 'spirit,' a belief so reminiscent of the U.S. government's notion of itself as the lone guarantor of capitalist liberty."[1]

The war years had made New York a center for abstract art with the influx of such luminaries as Josef Albers, Hans Hofmann, Arshile Gorky, Lyonel Feininger, Naum Gabo, and Piet Mondrian. Already influential were Willem de Kooning, who had come from Amsterdam in 1926, and Jackson Pollock,

who had arrived from Wyoming in 1929. In postwar America, "the lone artist did not want the world to be different, he wanted his canvas to be a world."[2] By the mid-fifties, the momentum clearly lay with abstract expressionism. In an interview with Seldon Rodman, Adolph Gottlieb asserted, "Representational painting today serves no social function at all, has no utility value—magic, religion, flattering the vanity of the rich, etc.—as it had in times past. We're going to have perhaps a thousand years of nonrepresentational painting now."[3]

The realists fought back. Forty-six artists, including Milton Avery, Isabel Bishop, Charles Burchfield, Philip Evergood, Chaim Gross, Edward Hopper, Karl Knaths, Yasuo Kuniyoshi, Jack Levine, Reginald Marsh, and Moses and Raphael Soyer, issued a public statement that "all art is an expression of human experience" and charging that "mere textural novelty is being presented by a dominant group of museum officials, dealers, and publicity men as the unique manifestation of the artistic intuition." Despite work that was "highly diverse in style and conception," the forty-six artists were united in their "respect and love for the human qualities in painting" and their desire "to restore to art its freedom and dignity as a living language."[4]

At Cooper Union, where Witkin began studying in 1957 after a post–high school summer at Skowhegan, a war of manifestos raged between realist and abstract painters. Turning his back on his facility as a figurative artist, Witkin plunged into the experience of the gestural mark. "When I left high school, it

was as Jerry the prodigy. At Cooper Union, I found myself throwing the paint down and getting lost. Action painting was like getting drunk. The artists at Skowhegan had condemned abstraction as a cop-out. In some ways they were right. But one got to feel that the humanist image looked sugary; the abstract gesture looked tough and ready and harrowingly searching.

"It seemed to me that de Kooning was saying, I am in chaos, I'm searching for something, I will find in the void what I really want to find out. Levine seemed cushy, full of art history; he was saying, I will find out through my friends Rembrandt and El Greco how I feel about things. Guys like Kline, de Kooning, and Rothko seemed much more heroic; they were much more themselves."

The alluring style did not hold him for long. "I was an abstract expressionist for all of maybe three-and-a-half years. I was still doing some figurative things, but I didn't know how to approach the figure until I went to Italy and thought about it a lot. The figure has to be learned, through time, through life. At that age, I was interested in surface, in perfecting my technique. A young artist wants to show off his skills. When I got older, I realized I had to go for the life force first, then the parts of the body, and last, the technique.

"The introduction to abstract painting made me look at a lot of Oriental painting, which made me realize that the mark on a page was a universal claim of expression. Even though my marks later became figures, the energy behind them, with a paintbrush or a pencil, is really based on an expressive action. In my underpainting, I'm still playing with paint like an action painter, finding out what the paint is and getting good advice from it."

Musing on those years as a student, he says, "It takes so long to become an artist. School is like a playpen—and a prison. In art school, you go through the pretense of being intense. There's such a confusion of energies. You're willing to try anything. Eventually you can pinpoint the intensity and you realize a lot more and you become an artist. I think the word *artist* is too easily taken as a title. You must gain it the way an Olympian gains the right to be called a world-class athlete. As a student you're lightweight. You hope that you'll become a Sonny Liston, so your punch can really do damage. But it takes years to become Sonny Liston's right arm. When you go to your studio, it's a fight—a fight for your spirit to stay together. How do you put your life on the universal line of experience? How do you absorb people into a reality, so that they'll say, 'Yes, that's true, this is truth. I was there, too'?"

While Witkin was developing his painter's punch, his twin was leading a dramatically different life. Joel had acquired a camera at the age of fourteen, and was clearly talented, but the roles had been handed out early on: Jerry was the family artist, Joey the prankster-hoodlum—a regular guy, at a regular high school. "I had the early success; he was shut out," the painter says. "During our childhood, we were close psychically but not emotionally. We didn't choose to be together, we felt chained together:

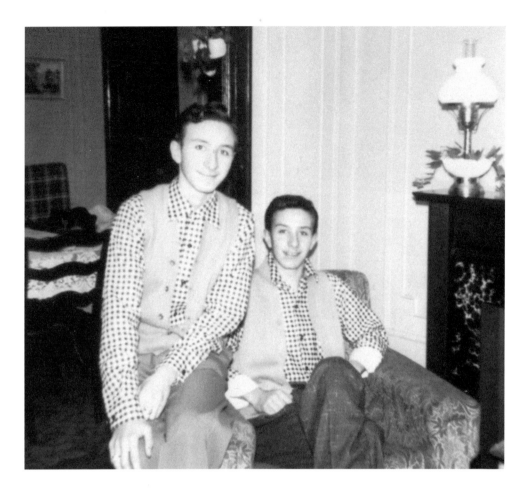

the cute sideshow. And everyone exacerbated the competitiveness between us. Joey was the more aggressive of the two of us. He was the first to rebel against our wearing the same clothes. He got involved with street brawls, and took great chances with the local bully. When he joined the army, it was partly a desire for action, but also to get training in photography and film."

"He worked as an aerial photographer, and was in charge of the entire photography unit," Mrs. Witkin recalls. "After he got back, he developed his talent, and he was accepted by the galleries right away."

While his twin brother was taking forensic pictures of military operations at Fort Hood and in the Black Forest of West Germany, Witkin was continuing his studies at Cooper Union. Upon his graduation, he won a Pulitzer Fellowship to Europe. As with so much of his early artistic development, it was his mother who functioned as the catalyst. He had begun a large painting, *Genesis,* for which Mary Witkin had posed as Eve. "He wasn't satisfied with the way it was going," she remembers. "He was going to destroy it. I said, 'Please don't, I'll even buy it from you if you finish it.' He went on with it, and I still have it hang-

16

ing on my wall." Grudgingly, Witkin submitted that painting to the jurors for the Pulitzer American Travel Fellowship, and it won him the prize. "That picture, and my mother's pushing, did it for me," he admits.

Before leaving for Italy, Witkin paid a visit to his father. "He was on medication. I went to help him out of his chair. He turned to me and said, 'Go to hell.' Those were his last words to me—he died while I was in Europe."

In Florence, Witkin found a room just across from the Pitti Palace. He spent much of each day in his room, trying to capture the light falling upon the sparse furnishings there. On his twenty-first birthday, he met Giorgio Morandi. He had written asking if he could visit, and Morandi's sister had responded with an invitation to do so. Witkin hitchhiked to Bologna, found the house, and rang the bell. Once inside, he was asked to sit in an antechamber while a well-known book designer took his leave. Then he was led into a little room with a big north window. There were Morandi's bottles, collecting dust. And there was Morandi, huge in size and presence.

"I felt so uncouth, but his kindness made me feel welcome. I gave him the two best things I'd done, and he said he'd give me two of his, but that they weren't in his studio; they were at the country house. I remember our conversation so clearly. He said 'What's most amazing is reality—reality is the springboard for all art, whether cubism or surrealism.' He'd look at those bottles, and they'd become people, music; they never remained just little bottles. He knew the

worth of his work, but he never became commercial; he gave his things away, because he felt he'd been given the ability to do them.

"Morandi never traveled if he could help it. He was a solitary guy; his life was protected by his sisters; it was very lowkey. I asked him, 'How do you know art if you never see any original paintings?' He replied that he trusted his feelings through the reproductions. Morandi was quiet, unassuming, but memorable, with an artist's sensibility that was stronger than the times around him."

Witkin returned to his room in Florence and remained there another four months. The room itself seemed to have a strong presence; Dostoevsky, an occupant at one time, had written a story there. It had no electricity; Witkin gained precious insight into how earlier painters had studied and used natural light. And Florence itself, with its cultural layers, its centuries of art history, mesmerized the young painter. When he left at last, it was for Rome, where he met a number of American sculptors and painters, was introduced to Fellini, and acquired a dealer, Charles Moses, on via Margutta. But all else paled compared to the experience of encountering the Caravaggios in the churches. "Caravaggio was the real thing, in person, just as Morandi had been. I fell to my knees. That commitment! Caravaggio's stories!"

From Rome, Witkin went to Berlin, where he explored "the nature of angst." He spent three months at the Berlin Academy and became good friends with Karl Schmidt-Rottluff, one of the founders of Die Brücke group, then in

his late seventies. "The art scene at that time in Germany was nothing like the neo-expressionism of recent years," he notes. "I heard nothing about Joseph Beuys or Anselm Kiefer. The German art I saw then was mostly witty cubist-surrealist stuff, a chalky mix of Chagall and Beckmann. I found its stunty brutality curiously beautiful, though."

The Berlin Wall had not yet been constructed, but rumors were flying. "They had closed the boundaries. Some of the students I met in East Germany were really anxious to get out, and I was asked to dig tunnels. I could use my passport to visit East Germany as often as I wanted to. But I knew my own naïveté. I didn't want to get caught and put in some East German prison. I couldn't save anybody that way; but it made me think that I could save somebody in another way, through my painting."

It was not until many years later that Witkin would investigate Germany's dark era of Nazism, and then it was, characteristically, on the canvas. "At the time, I just wanted to get a lot of painting done. I just wanted to live in the present, to see paintings, to compare cities and cultures. It was an artistic pilgrimage. The political consciousness came later."

Witkin traveled on to Venice, through North Africa, and up to Sicily and Naples, where he was struck by the late Etruscan paintings at the Museo di Napoli. "I was in my early twenties; everything seemed brand-new, and my life was like Fellini's *La Dolce Vita*. I felt so connected to my heritage—Italy, Germany—and I was amazed at how impor-

tant painting, opera, all the arts were in Europe. My education peaked at that point."

Upon returning to the United States, in the first three months he won a Guggenheim Fellowship, was hired for his first teaching job, and was given his first solo show, at the Morris Gallery, in Abington Square, Manhattan. "My first review was from a street lady," Witkin recalls. "She looked in the window and said, 'Whoever did this is crazy!'"

Mary Witkin presided at the opening, ladling out punch and basking in the glow of her son's success. "I was so proud of him," she says. "I always praised him for his talent from the earliest years on. He knew he had something, but whatever he did, I said, 'That's great,' no matter what it was. I still feel that way." Joel-Peter was not at the gallery; he had volunteered to serve as the official photographer for the invasion of the Bay of Pigs. Sara was present, however, and her words to her brother would resound over the years: "You're so lucky, a poor boy getting to know all these rich people—you'll get out of Brooklyn now for good." Not only did the show serve to introduce Witkin to several major early collectors, but it also brought about his long-term relationship with Antoinette Kraushaar, who launched his career at Kraushaar Gallery soon afterward.

Although he was maturing rapidly as a painter, his personal development was still shaky. Mrs. Witkin accompanied her son to his job interview at the Maryland Institute's College of Art in Baltimore. "I had an extreme psychosomatic hayfever

reaction that day," he remembers. "The president must have thought, 'Who is this weepy guy we're hiring who's here with his mother?' I was sniffling uncontrollably throughout the interview," Hired despite his own misgivings, he began teaching there. Soon afterward, he met Kieny Pompen, a young woman from the Netherlands who was working as an *au pair* for a Baltimore family. The couple decided to marry and traveled back to Europe for their wedding and honeymoon.

Witkin continued teaching at the Maryland Institute's College of Art until 1965, when he was offered a two-year position as a visiting artist at the Manchester College of Art in England. During that period abroad he produced a series of collages on photosensitive paper with acrylic paint. Looking at these pieces, we can see his early fascination with edges, with fragmented and pieced-together segments of reality, with the collision of dream and waking states, with transparency and silvery reflective surfaces. Glowing color is offset by murky shadows, areas of dusty obscurity, eye-swallowing blacks. One collage in particular seems to be a direct precursor of *Division Street*. Its imagery includes a child's head and back, a coat flung over a chair; legs and shoes, depicted from a child's vantage point, loom over the viewer.

The Witkins' son, Christian, was born during that first year in England; toward the end of the second, Kieny was pregnant with Gwendolyn. The artist's delight in his son merged with his anxiety about the future in a canvas he painted there called *Rape in the Pencil Factory,* in which imagined horrors are interwoven with such domestic images as diapers, a mother's legs, a baby in his crib.

Witkin's next job, which he looks back on as "teaching art history to rich people's kids," was in Switzerland. It was there that he painted his first major political narrative, *Vietnam,* depicting a man stepping out of a shower. In the steamy mirror the man sees not himself but a Vietcong soldier, barely discernible as he moves swiftly through the frame. "I wanted to show the sense of sameness an American soldier might have felt with the other guy," Witkin says. Throughout that European period Witkin showed and sold works at various galleries in England, including London's Grosvenor Gallery. He also arranged two photography shows for his brother, one at the American Embassy in London and another at the Manchester College of Art.

Eager to return to the United States, Witkin applied for a teaching position at Moore College of Art in Philadelphia. After learning of his acceptance, he also enrolled in the Graduate School of Fine Arts at the University of Pennsylvania for his master of fine arts. The Witkins found an apartment in Philadelphia. Now teaching, painting, and graduate work absorbed nearly every moment of the painter's time. "I tried to be a good father, but I was too self-absorbed and too absorbed in my art," he reflects. Moore itself, a women's college, was no Eden. "The perfumed jungle" was how Witkin referred to it, shocked out of his

innocence by the political schemings of academic life. Not long afterward, Kieny returned to the Netherlands, taking the children with her.

In 1971 he was offered a job at Syracuse University's School of Art. He threw himself into his teaching and into the large canvases that prefigured his mature work: *Days of the Week* (1974) (fig. 6),

Loss of Innocence (1974–1975), *Alive Alive O* (1975) (fig. 7), and the particularly important transitional paintings *Kill-Joy: To the Passions of Käthe Kollwitz* (1975–1976) and *Painter's Crossing: To the Passions of Rembrandt* (1976–1978).

Jerome and Kieny were divorced; in 1974 he married Judi Fliszar, whom he had met while teaching at Moore College

Fig. 7. *Alive Alive O,*
1975. Oil on canvas;
42 × 72 in.
Collection of Peter S.
Myers, Pacific Pal-
isades, California

of Art. During the summer of 1975, he spent several weeks painting landscapes, inspired by the beauty of the Central New York countryside. Pondering the color green, he wrote in his journal, "I used to believe that it was all broccoli. But the rich changes of greens are stunning. God is green and blue and white. The sphere of Earth itself is a moving, changing eye of God."

"Landscape," he wrote on another page, "is to me that balance point where dance, texture, light, sparkle, form, and air all meet. It suggests and can be states of mind of its selector. It can play wind against calm, brutal against soft, dark against light. Its textures force invention with the brush. I had to use palette knife, scumbles, glazes, *X*'s to create the small leaves in *The Clearing Area.* Also, the drama of eye-levels: looking at, looking up and down while you paint—is so marvelous on a large canvas." While studying the land was uplifting, he wrote,

examining the streets was something else again. "The streets equal human waste, loss, emptiness (Hopper). They're mean, neurotic, dream states (Grosz and de Chirico)."

As Witkin matured, he turned more and more to the streets as an expressive equivalent of the human condition, drawn by a growing sense of urgency to invest his art with social significance. Except for a few paintings of Syracuse buildings and industrial plants and a brooding, somber series of drawings done in Oregon, the landscape faded in importance, as did the still life. Now both became instead important and often symbolic elements of narrative paintings dominated by the human figure.

Whereas his earlier canvases had been executed in a blocky, volumetric style, with rather disjointed, isolated figures that looked as though they had been carved out of wood, the new work had a many-layered, shifting space and a flowing rendition of forms that suggested imminent change. In this work of the mid-seventies, Witkin's fascination with the distortions created by reflections in glass, with disfigurement and amputation, and with the conflation of the real and the simulated would find mature expression in such polyptychs as *Subway: A Marriage* of 1981–1983, *Mortal Sin: In the Confession of J. Robert Oppenheimer* of 1985, and *A Jesus for Our Time* of 1986–1987.

Early in 1975, just after returning from visiting his children in Amsterdam, Witkin jotted down in his journal a list of paintings he wanted to do. Titled "The Portrait Gallery," the list read:

Rembrandt—compassion
Van Gogh—reverence, then confusion
La Tour—serenity and silence
Hokusai—life! teeming with surprise
Kollwitz—emptiness and grief

He began with the last "portrait" on the list. Deeply moved by what he had read of Kollwitz's double losses—her son had been killed in the First World War and her grandson in the Second—he conceived of a painting in which Kollwitz (and we the viewers) would bear witness to a catastrophe, a public death. It was a theme to which he would return again and again in future works. Kollwitz, in this painting, would be the observer of "man's lowest acts, played out in front of her; she witnesses what she can't stop."

It was in this painting that Witkin made a breakthrough that was to transform his approach to the canvas. For the first time he envisioned his entire studio as a collage of elements to be combined upon the stretcher. Thus, he wrote in his journal, he could "make a more feeling and intuitive statement" that could "include surprises of light, space, angle, and size." He thought now of his collages made during his stay in England: "they had some wonderful surprises that I didn't even consider painting from!" The journal entry continues, "I wish to first collage the scene—blurs to sharp—surprises and changes in size and proportion *before* beginning the painting." For *Kill-Joy,* Witkin devised a black-and-white set made of cloth, as "textured and sooty as her [Kollwitz's] prints."

With its shattered storefronts, its torn marquee, its mutilated bodies and side-

walk death scene, *Kill-Joy: To the Passions of Käthe Kollwitz* (plate 1) carries strong overtones of Kristallnacht, and prefigures Witkin's Holocaust series. The connection, unconscious at the time, between the Kollwitz painting and those documenting the Nazi atrocities is pointed up in a one-line notebook entry of 1978: "Kill-Joy '33–'45, the War against the Jews."

Witkin has always been intrigued by Kollwitz's ability to convey the surging power of the lived moment. "You leave one of her works *caring* about human beings," he says. "That's what I want: art in which people are showing that they care." What, then, could be more dreadful than a world in which joy has been replaced by apathy, pain by numbness, passion by indifference? In *Kill-Joy* and in most of the major works that follow it, we are asked to consider what it is to be human. Is it not, Witkin suggests, the capacity to suffer, and to regard others' suffering with compassion—with passion, *con amore?*

In this painting, we are on the inside looking out. We are positioned among the broken mannequins, the simulacra of humanity. The real thing is seen through the shattered storefront window, across the street: a woman cradling the lifeless figure of a man, one bare foot exposed (while a woman's shoe—from a store? from his companion?—floats in a slow trajectory near his head). It's an ancient gesture, this grief-stricken enfolding of a fallen figure, this pietà.

From this important painting on, we see Witkin plumbing every thought, every image for its allusions, its para-doxes. In *Kill-Joy,* as we piece together the shards of glass to find the pattern, as we decipher the shifting planes of reflections, we discover level upon level of meaning. Iconographic references abound. Central, of course, is the *pietà,* that universal symbol of woman's grief for man slain by man. In the foreground on the right we see a mannequin whose pose echoes that of the Libyan Sibyl on Michelangelo's Sistine Chapel ceiling. Charles R. Garoian, education director of the Palmer Museum of Art at Pennsylvania State University (which owns *Kill-Joy*), notes that this sibyl is a female prophet "who foretells God's creation of light out of darkness and order out of chaos."[5]

In the lower foreground, with its bald head in profile, is a mannequin that brings to mind a Buddhist monk. The figure, seen again in a reflection behind the entwined and upraised hands of the man and woman, reminds us of those Vietnamese monks who, seated calmly in the act of self-immolation, performed that ultimate protest against the systematized murder called war. Monk-like, too, in an attitude of prayer, is the fallen mannequin near the man's bare foot. Again, we reflect on the title, *Kill-Joy,* and think of the Buddhist response to suffering: a compassion founded on dispassion, a cutting loose of the bonds of ego, a killing of attachment to joy.

Just as the man and woman on the street epitomize grief, these mannequins embody, in their hollow fragments, Kollwitz's passion of emptiness. It is significant that these wooden figures display no ordinary attire. They have been placed in

their showcase to advertise the store's specialty: devices for maimed and damaged bodies. Supports for injured parts, incontinence underwear, artificial legs and arms—the sort of gear required by amputees, perhaps themselves the casualties of accidents or war, that emits an unavoidable aura of loss, of "emptiness and grief."

Broken bodies, broken glass—broken connections, too. For the pair of mannequins in the foreground, what is implied is a shattering of the sexual. The figure wearing an incontinence garment is severed at the waist; its (defective) crotch is positioned a charged few inches from the kneeling figure on the right, buttocks exposed, phallus implied by the flesh-like diagonals of cracked glass. And across the street, death has rent asunder the couple on the sidewalk, their clasped hands to no avail. Those hands, mirrored

in the storefront behind them, form the shoulder of the monk-mannequin reflected from the foreground. We search those mostly intact storefront windows for information, for clues to the crash or explosion that has occurred on the street or in the medical supply store that is our vantage point, and we find no answers: simply the contents of the clothing store across the way, the reflected streetscape.

Gestural brushwork flies over carefully composed and modeled forms, at once defining and defying their volumetric status; light shimmering through slivers of glass creates a kaleidoscopic complexity of surface, a cubist fragmentation that taunts the Renaissance illusion of perspectival space. A tour de force of swift movement and blocked action, the painting brings together all the disparate influences of Witkin's training.

24

III ❧ THE HUMAN CONDITION

WE ENTER the left panel of *Death as an Usher: Berlin, 1933* (plate 6) along with the bullet. A Brownshirted arm extends down into the painting from our space, outside the canvas. The harsh diagonal of that arm, that hand with a gun, pulls us further downward. A woman crouches in slack-jawed horror over a man slumped on the pavement. Against the darkness of the unlit store window, the black of the woman's dress, and the black of the victim's suit, are contrasting moments of illumination: the hands of the killer and the kneeling woman, the backs of her white-stockinged legs, the edges of the yellow six-pointed stars she and the murdered man wear.

The dead man's black hat, lying at the midpoint of the panel's lower edge, tilts upward, leading us diagonally past the overturned garbage can to the pale figure of a girl dressed all in white, with long blond hair. One hand clutched at her chest, the other held tensely in front of her, mouth wide open in a silent scream, she runs from what she has seen, runs toward presumed safety. Close behind her

and facing in the opposite direction is another woman, dark-haired, her hand clamped over her mouth; one leg projects toward the murder scene as her body arcs back, her progress along the sidewalk abruptly halted by the shooting. Despite the fact that the dark-haired woman is the farthest away, she is larger than either of the women in the foreground—a subtle yet effective wrenching of the viewer's trust in the illusion, and one that aptly conveys the savage unpredictability of the period portrayed. Her head and that of the running girl seem connected from our perspective, like a female manifestation of the two-headed god Janus—symbol of past and future, beginnings and endings, openings and closings.

In true cinematic progression, the middle panel shows the running girl a few steps further along, nearing the ornate door of a theater. The narrow, confining space of this panel, underscored by the tall rectangles of the partially open door and the plywood-covered windows, suggests further confinement; we think of boxcars, of coffins. There is no

place of refuge for the Jews of Germany in 1933, and worse is yet to come; their flight is toward the "final solution."

The V-shaped composition of the first panel is repeated in the third. Here a theater usher helpfully shines his flashlight upon the now-dead body of the girl in white; the beam is a dagger, its blue light reflecting eerily upon the usher's grinning face and beckoning hand. To whom does he beckon? Back to the running girl as she approaches from the central panel—and the blue light of death, we now realize, traces her upraised arms and thighs delicately in the first panel, and floods her face and body (as well as the doorway) in the second. In this final panel, the girl is being dragged off by a sheep (the obedient follower of orders). The theater's interior is an infinite progression of mirrors, and in each, growing smaller and smaller, is a sheep's head. We quickly understand that this scene of violence is being repeated over and over again, and this is just the beginning. It is only 1933, five full years before Kristallnacht, the Night of Broken Glass, when the Nazis destroyed countless Jewish homes and shops (the accounts of which were on Witkin's mind as he worked on this painting). It is only 1933, and yet well-organized Nazi mobs have been plundering Jewish shops, beating and killing Jews on the streets. With the official investiture of Hitler and the Nazi Party on January 30, 1933, these random acts are increasingly becoming part of a carefully orchestrated plan. In *Death as an Usher: Germany, 1933*, the Holocaust is being ushered in—on the streets and in the shops, homes, schools, and theaters.

In this tribute to the six million Jews murdered during Hitler's reign, Witkin uses the triptych format, often associated with representations of martyrdom. The paired *V*-shaped compositions that frame the central figure freeze the girl's desperate flight. The tall, vertical middle panel is flanked by long, horizontal side panels; the shape suggests a cross, perhaps an unconscious reference for a painter raised to associate martyrdom with Christ's crucifixion.

When Witkin began this painting in 1979, he envisioned it as a sequence of moments on a street. Among its initial titles were *A Devil Within*, *The Hitler Picture*, *Still Life*, and *A Street Scene, Berlin, 1933*. "It should suggest Berlin of 1933, but have the presence of any street," he wrote in his journal. The scene should symbolize "a seedy, dirty, filthy, corrupt Germany." Pondering what such a street should look like, he jotted down lists of props he'd need to set the stage: "cigarette butts, dirt, broken bottles, dog shit, weeds, bits of newspaper." The depiction of the details of such a street would "help the 'place' of the picture. Just like the Rembrandt picture [*Painter's Crossing*], a reality closes in."

In a March 1980 entry, he listed the following "New Devices" for what he was then calling *Still Life*: "1. The simple composition and simplified color. 2. The emotional gestures of the figures and hidden gestures of the two [at the time] killers. 3. Shallow space and a subtle deep space in the reflection. 4. The underneath play of light on the crouching woman's face and the garbage can. 5. The harsh comparison of the dead figure and

the garbage. 6. The play of the white stockings to the white blouse. 7. And the brown rust to the shirt near it. 8. The shape of this picture. 9. The play of bright orange (near full strength) near the left group to heighten the emotion and area. 10. The men on the sides fading into the areas."

To intensify the psychological trauma of the scene he envisioned, the artist brought 100-watt floodlamps close to his models, "causing, like Caravaggio, a kind of 'thunder-clap' light," he wrote, with "the shadows as pattern (to hold it together)." As the picture developed, Witkin was struck by the idea of using a theater as the scene for the grand finale. He began spending days at a time at the richly ornamented old Loew's State, designed in 1928 by Thomas W. Lamb, who described it as "European, Byzantine, Romanesque—which is the Orient as it came to us through the merchants of Venice." (Threatened by the wrecking ball, the movie palace was acquired in 1977 by a not-for-profit corporation and preserved as the Syracuse Area Landmark Theater. An ambitious campaign to restore it to its former glory continues.)

Positioning himself at various spots in the outer main lobby, with its brass and stained-glass doors, its murals on walls and domed ceilings, its silk tapestries, and in the inner lobby, with its brass cobras holding sconces in their teeth, its floor-to-ceiling mirrors, regal staircase, and wrap-around balcony, Witkin made sketch after sketch, focusing particularly on the ornate doors and mirrored walls. For the first and second panels, he had created a theatrical set in his studio,

strewing detritus on the floor to resemble an abandoned street. For the third panel, an actual theater had become his set. By the spring of 1980, he was calling the triptych *Death as an Usherette*. He had begun depicting a woman in uniform collecting the young girl's ticket and leading her into the darkness. Then he was struck by the notion of using a sheep to drag her away. The pages of his journal from that period are filled with sketches of sheep; a tentative title for that third panel is jotted down among these drawings: *Home Movies: (The Golden Sheep)*.

"We see what the running girl sees," he wrote in his journal of 1981. "She moves between the reality she's leaving and the still crueler reality she's entering, the prophecy of the Final Solution. . . . We go from light to darkness, from panic to hysteria, from the unseen gunman to the smiling usher that is Hitler."

From the late 1970s through the early 1990s, Witkin returned again and again to the dark era of Hitler's Germany. "It seems to me that Hitler was a hate-genie," he wrote in his journal during the summer of 1978, "a manifestation of the collective dark side of the human heart and soul." Reflecting upon the preliminary sketches he was working on, he wrote, "The subject matter is assuming such an epic and unattractive nature that I'm finally saying goodbye to 'nice' and 'pretty' art." In a 1979 entry he asked himself, "Why are you painting such a horrible picture? Aren't the times ugly enough? Why make more ugliness to look at?" His defiant reply, scrawled across the top of the page, is, "One paints the times one lives in!"

Fig. 8. Gwendolyn and
Christian Witkin,
Beethoven Straat,
Amsterdam, 1974

While working on the first stages of
Death as an Usher, he was completing a
single-paneled painting, *The Devil as a
Tailor* (plate 3). He saw them as two seg-
ments of what he envisioned as a five-
part sequence on the Holocaust (later to
become six).

"I have to do the five-painting series!"
he wrote in February 1979. "It's right and
intuitive for now. It's life, our times, my
state of mind, and a reflection of this crit-
ical and sordid world of ours."

In another entry he wrote, "I'm saying
'fuck you' to Nazism and all that is eter-
nally stupid and ignorant and violent in
all governments and in ourselves."

The *Devil* painting, in early sketches,
was envisioned as *The Devil as a Cook,*

but soon evolved to the tailor theme.
"Should the Devil be syphilitic," he
mused in his notes, "or appear normal?
He must appear more isolated, exposed,
and forbidding."

There are no windows, no mirrors in
The Devil as a Tailor. The cluttered space
is dense, claustrophobic; we are only
inches away from the pudgy pink figure
in spectacles who regards his work with a
satisfied smile. Hung on hooks and piled
on boxes around him are the garments
he has sewn: a gabardine coat with a yel-
low star bearing the word *Jude;* two Nazi
uniforms, brown, with officers' insignia;
some indeterminate khakis, a red shirt,
and a couple of hats dating back to ear-
lier wars. The Devil's right hand is raised,
holding a needle with delicate precision.
The needle is about to be thrust into the
garment on his lap: the striped uniform
of the concentration camp inmate. The
Devil is dressed in sumptuous robes of
an earlier era, Napoleonic gilt and bro-
cade ornamenting the shoulders, wrists,
and hem of his garment. A heavy blue-
black drape has been pulled back at one
side, as if to reveal this small congested
theater, this cell of industrious activity.
On the ornate sewing machine is a spool
of blood-red thread. The red is every-
where echoed: it bathes his face, the wall
behind him, his knee; it seems to spill out
into the very air around him, mottling
the shadows cast by his throne-like chair.

We cannot escape this scene. Its focus
is intense and electric. With its uncom-
promising repetition of verticals (the
uniform, the hanging coats, the chair
and its shadow, the wainscoting of the
wall, the heavy drape), its agitated brush-

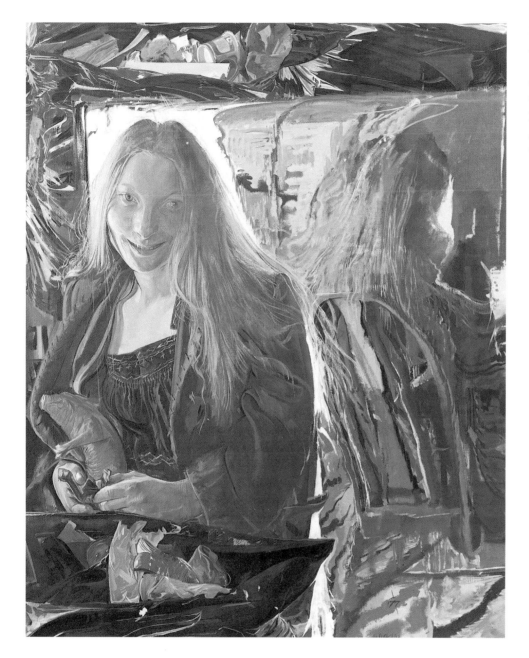

Fig. 9. *Madonna della Baggies (Portrait of Felice Dulberg)*, 1977. Oil on canvas; 60 × 48 in. Collection of Butler Institute of American Art, Youngstown, Ohio

work, its frenzied blur of scumbled and rubbed-out forms, its suffocating density, the painting vibrates with anxiety and apprehension. The model for *The Devil as a Tailor* was a young man Witkin met by chance. Sebastian Niedecker was "short, about twenty, and totally bald, wearing wire-rimmed glasses on a small red nose," Witkin noted in an article for the Winter 1979–1980 issue of the *Syracuse Scholar*. "He had a long slice of a mouth and a flimsy gray-brown beard

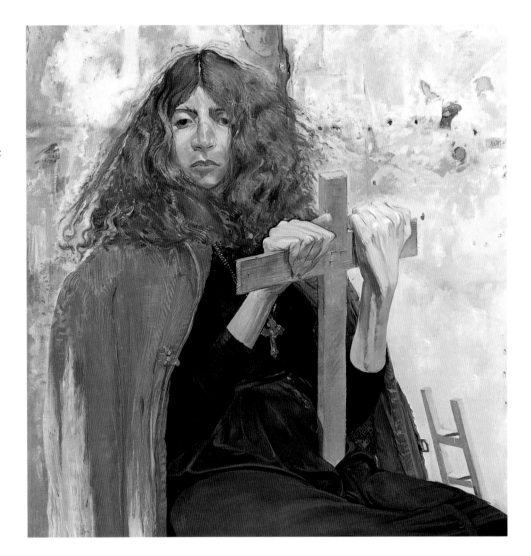

Fig. 10. *St. Fischera*, 1977. Oil on canvas; 50 1/2 × 48 in. Collection of the Memorial Art Gallery of the University of Rochester, Rochester, New York (gift of Eric Greenleaf)

that grew only from his chin—a beard resembling the tapered horns of a unicorn formed somehow of smoke. 'I'd like to paint your head,' I said to Sebastian, using an expression that made sense to anyone interested in portraits. Sebastian immediately agreed but thought that the next day I would be painting a floral design on his bald head!"

The first-time model brought along a wizard costume. Witkin positioned him in a large oak chair on the enclosed, stage-like platform, with its hidden theatrical lights, that functions as a set for many of his narrative paintings. "As I looked at him, smiling in his long robes, it struck me in that instant that here was the devil and not some costumed wizard. Sebastian loved the idea! My collection of prop costumes turned this devil into a tailor—a tailor of all costumes of death."

In Witkin's journals of this period, interspersed with the sketches of figures emanating cruelty or anguish, malice or

terror are reflections on his children, who spent each summer with him and Judi in Syracuse. "I've armed myself with terrific books (and pictures) for the project," one passage reads. "I've read a lot and know more about the Nazis and especially Hitler's crazy and warped ideas and mind." The very next passage begins, "This summer was the best and easiest and most natural. [The children] love and respect me and I had the right state of mind with them." Elsewhere in the same notebook, he wrote of a late-night moment of intimacy with his son: "He remembered . . . my promise to tell him about Max Witkin. I did, and to my surprise, very objectively and warmly. I told C. that Max was very good at his work and his friendships . . . [but] that you couldn't get five out of five in life, couldn't be equally good in all things. I said Max Witkin wasn't a good father. Then Christian said quickly and matter-of-factly, 'You are!' My heart broke. I was deeply moved, and couldn't stop the feelings. Couldn't open my eyes (the flood-gates and all that) . . . I am a Good Father!"

During this period, Witkin began exploring portraiture as a vehicle for psychological narrative. Working with the model as a collaborator in mutually created dramatic poses, he developed an epic portrait style using mythology, both historical and contemporary, to probe his own and others' anxieties, fears, and fantasies.

In the 1977 *Madonna della Baggies (Portrait of Felice Dulberg)* (fig. 9), a suffocatingly shallow space is crowded with plastic food bags, a yogurt carton, the re-

Fig. 11. *The Screams of Kitty Genovese* (detail), 1978. Oil on canvas; 58 × 84 in. Collection of Joseph Erdelac, Cleveland, Ohio

mains of a fish (for centuries, a symbol of Christianity), and other detritus. The space is broken by a mirror. An almost blinding light bathes the figure's hair, the side of her face, chest, and hands, and is reflected in a halo-like swath around her head and down her back. Cradled in her arms is the Holy Child—here, represented by the fetus of a pig. Seemingly an image of sacrilege, for Witkin the scene represents "a crazy Madonna for a crazy world."[1]

On Dulberg's long, oval face is an expression hovering between the reverent and the goofy, the mystical and the satirical—akin to the *sourire universel* in the portraits of Maurice Quentin de La Tour. The gestural treatment of the reflected light and space surrounding the figure makes the border between the real and the mirror image an ambiguous one;

like *Painter's Crossing*, this is an early example of Witkin's obsession with doubleness, with the blur of identity between self and other.

In *St. Fischera* (fig. 10), painted that same year, the space is atmospheric, undefined. As in *Madonna della Baggies*, it is divided vertically down the middle. The split is reinforced by the wooden cross the model grips, a sharply pointed cross that is embedded in her crotch—a stake upon which she has been impaled. We read the small ladder that leans against her leg as a metaphor for her ascension to sainthood through sexual martyrdom.

Martyrdom of a more violent nature is the subject of Witkin's 1978 canvas *The Screams of Kitty Genovese* (plate 4, fig. 11), although here the nightmarish act occurs offstage, as it were; what is depicted is a sound that interrupts a postcoital moment of ordinary life (the woman smoking a cigarette on the edge of the bed; the man all but out of the picture frame, pulling on his pants; a cup of tea steaming in the light that floods the room). The lovers pause briefly to register the desperate cries for help outside their window but are clearly disengaged:— from the murder taking place just yards away and from each other. The man leans in from the left edge of the painting. His diagonal posture is echoed by that of the woman's arms, the tilt of her head, and her dangling leg, by the position of the pillows and the geometries of pajama and quilt patterns, and by the beams of light coming through the window. The eye is directed sharply from left to right, ending at the open window; despite the fact that this is a single-paneled painting, its strongly horizontal scale (58 × 84 inches), its directional thrust, and its implied sequentiality (the sounds of violence "heard" but not seen) give it the cinematic impact of Witkin's polyptychs. The painter would return to this pictorial representation of sound in such works as *Are You Here? Sue Ades Posing* of 1985 and *Unseen and Unheard (In Memory of All Victims of Torture)* of 1986.

The immediate aftermath of a murder is depicted in the 1979–1980 canvas *The Act of Judith* (plate 5). Staring intently out at us, blood dripping from the knife she grips in one hand and from the decapitated head of Holofernes she holds in the other, Judith stands with uncompromising frontality against a dark void (passageway to the netherworld), having acquitted herself of a messy but necessary task. The ruddy pink of her blouse and of the brick wall to her left are like reflections of the bloody forms that project toward us.

Prefiguring the 1981–1983 polyptch *Subway: A Marriage,* in which a doll is used to represent a baby, here a mask stands in for Holofernes' head. For Witkin, painting from life means painting what he sees, not approximating from his rich store of fantasies. Through his use of theatrical props, he heightens the tension between illusion and reality. And masks, like mirrors, are intriguing metaphors, suggesting self-deception, hidden truths, and the possibility of revelation. Both appear frequently in his work.

In June 1980, just after finishing *The Act of Judith,* Witkin wrote, "I have a

feeling that with the violence of my new work for my next show, I'll be seen as a demonic street-crazy, celebrating harsh and hard subjects." By the end of the year, he was feeling the need to take a break from such subjects, particularly from the ongoing work on *Death as an Usher* (plate 6). "I wish to put a pause in making the triptych," he wrote. "It all gets too morbid and depressing." He decided to begin a series of full-figure portraits, in which he would work with the model to create a theme or psychological ambiance. "Each picture is about the person participating in her own costume and attitude. She and I will agree on the experience [to be portrayed]. The problem is to suggest a place and atmosphere and see all the model's gestures, body parts and the space at once."

A principal work in this series is Witkin's portrait of Claudia Glass, whom he described in his notebook as "a beautiful and melancholy young woman [who] wishes to be seen as elegant (read sexy). And she is." Artist and model agreed upon "the experience" the painting would invoke: "the end of a New Year's party. . . . The party's over; party-girl; a bad-good time. After the party (life) comes Death." Witkin positioned the model in an alcove built especially for the painting, and scattered party streamers and other New Year's Eve favors about. In the foreground, between a skull and an ashtray filled with butts, he tossed down an old coat, which we recognize from *The Devil as a Tailor* (plate 3).

Initially a portrait in profile, in which the figure's face was shrouded in darkness, as it developed Witkin felt it needed

to be restaged. "We should see her head first, not the skull," he wrote. "Try for a sweaty presence, [conveying] a drug-oriented existence." To offset the skull at her right side, he now placed at her left a tall, tubular glass water pipe with a serpentine tube, the sort sold in "head shops" for smoking hashish and marijuana. In addition to the changes in the pose and in the lighting, he positioned a white panel behind Glass's chair, and suddenly everything came together: the brightly lit figure, the green-blues of the backdrop and floor, the shadow no longer an enveloping shroud but an echoing, sinister form. Playing on the twin symbols of death and drugs, he had his title: *Headstone: Portrait of Claudia Glass* (plate 8). It is indeed a sexy painting, in the time-honored tradition that associates sex with death, drugs with abandon. The model is bathed in a rosy light, heightened by the old piano shawl that has falled from her shoulders. Her skin glistens. Smoke from her cigarette and from the hookah zig-zags in the blue-green darkness around her and through the long, kinky strands of her hair. Her jaw slack, her eyes glazed, she sits in her black patent leather spike heels, her black slip of a dress pushed up to her crotch, as if awaiting death's embrace.

"In 1981, if I can finish the triptych and get the new portraits finished," Witkin wrote, "then I've improved not only the large picture idea but the intimacy of the portrait." He added, "I love the sincerity of Eakins, his deep wonder in reality." After a notation regarding a technique he had just begun using, in which he

scumbled "tomato-color on (over) the first skin of the figure, to develop that subtle blood-glow," he continued musing. "The artistic triumph is so illusive. The doubts get thicker, but the appreciation grows! This time is not for the spirit-glow but for its darkest doubt. O God, give me the time and the luck to move the mountains of doubt and reach the light of your visions."

In a later passage, written after seeing the film *Elephant Man,* Witkin told of his emotional response to the portrayal of "the heights of man's goodness and the lower depths. . . . We come out triumphant. We have it in us to be so godlike and large and again as small as sheep. How marvelous to create a film that causes its audience to be silent and moved. Pity painting can no longer do the same (in most cases). Raphael Soyer at his best can touch deeply. God help me to gain a more trusting and loving heart."

Soyer himself had been struck by the compassion of Witkin's brush in 1976, when he had written a catalogue statement for the Everson Museum of Art's show of portraits by Witkin and a fellow Syracuse University art professor, Gary Trento. Unlike other young realists reacting against abstract painting's "sterility, its negation of life and reality," he wrote, "Witkin's work is less harsh, more subjective, more poetic, more involved with the content of what he is painting. It is emotional, even impetuous. His paintings fairly crackle with life, light, and color. Courageously and adventurously he attempts compositions of epic character."

During the summer of 1981, while finish *Headstone: Portrait of Claudia Glass* and immersing himself anew in the final stages of *Death as an Usher,* Witkin began what would turn out to be one of his most important polyptychs, the four-paneled painting *Subway: A Marriage* (plate 7). Wedged into his journal of this period is a news item clipped from the *New York Times,* the headline of which reads, "Brooklyn Man, 47, Shot at IND Subway Station." The real-life incident became an ingredient to be tossed into the simmering cauldron of Witkin's dream images.

Among his notebook sketches of a man standing in a subway car, caught up in a dream that reveals his secret fears, is a reference to "Little Nemo comics for their space effects." About such "space" he wondered, "Real three-dimensional space is known, but what about nightmare and dream space? How to present its terror and its strong appeal and hold?" Reflecting on his Holocaust paintings, never far from his mind, he added, "It becomes interesting that the triptych is part nightmare, as is *The Devil as a Tailor*" (plate 3). First approached in the 1971 canvas *11:43 A.M.,* and then in the 1974 *Days of the Week,* the space of dreams would draw Witkin back again and again, in paintings like *This House on Fire* (1983) and *Her Dream* (1987–1988). The related realm of reverie and transfiguration would be explored in *Suddenly* (1986) and *A Jesus for Our Time* (1986–1987). In a further entry regarding *Subway,* Witkin wrote, "The dream is the visualization of the husband's frustrations with his wife. The narrative is his marital situation—

this now becomes readable and sharable." Witkin's dramatization of a male figure who is acted upon, vulnerable, and trapped in circumstances of his own invention is, like the 1984–1985 triptych *Division Street* (plate 13), rooted in the artist's past—here, the confused and irresolute period of his early adulthood.

As we scan the four panels of *Subway: A Marriage* (1981–1983), messages abound, but the writing on the wall is illegible save for the words "good" and "do come." As metaphors for marriage go, this one is particularly grim: entrapment in a subway car filled with menacing figures, graffiti obscuring the maps and signs, the screech of metal against metal, harsh lights flickering and going out just as the cast of characters grows truly terrifying.

If dreams do indeed have a revelatory power, what is learned by the sleepwalker, the silent narrator? The pajama-clad figure seems to hover above the floor of the subway car—a floor so fluidly, vaporously painted as to refuse even an inch of terra firma. His eyes are closed; panel by panel, his interior vision unfolds before us. Two serpents, symbolic of the twin forces of sexual generation and death, coil at the sleepwalker's feet. He clutches a pillow, which can be read simultaneously as a sack, out of which, perhaps, the snakes have slithered—a sack still filled with further manifestations of the unconscious, harbingers of dreadful acts.

On a table nearby lies a mannequin's hand, an inert model of that most evocative form. Severed as it is here, it tells of abandonment, of lost protection, lost

faith. And if what Aristotle called "the tool of tools" is separated from its body, who can take responsibility for its deeds? Like the hand, the baby in the next panel is represented by a representation of a baby: a doll, held by a figure draped and hooded in black, a nightmarish twist on the nuns of Witkin's youth. The figure bears a knife in a hand that is paw-like, barely human. The knife is pointed toward the doll's chest (and the sleepwalker's crotch). The doll wears the same kind of pajamas as the man; while the doll's face is all but featureless, now the man's is contorted by his shattering premonition; his body writhes with inner torment, feet pointed one way, head, shoulders, and clenched hands another. The subway door is sliding shut. In the third panel, the wife-mother-witch-nun reveals her grinning face as she stabs the doll. Blood pours from the wound and, simultaneously, from a wound in exactly the same place on the sleepwalker's body. In true black-magic fashion, what is done to the doll is suffered by the human, the intended victim.

This cautionary tale concludes with the bleakest of awakenings. The sack is once again an innocent pillow in a landscape-patterned slipcase. The mannequin's hand of the first panel, the witch's claw of the middle panels, is now the outstretched hand of the man's wife, reaching out to reassure her husband: There, there, it was only a dream. But he is still rigid with horror; his eyes, open now, gaze blankly at the small bedroom. Around his feet is the debris from a nightstand he has presumably overturned (shattered glass from a fallen

painting, a telephone off the hook, a still-lit lamp, a torn sheet of paper with the artist's signature). An intense white light pours in from an unseen source, as in a visitation; dark shadows fall across the bed, tracing a thick outline around the upper half of the man's body. A vehemently green splotch in the darkness behind the bed echoes the green of the murdered doll. Just a trace of light catches the woman's profile.

It is a good story, as gripping as a Goya war scene, a St. John the Baptist by Caravaggio. There's nothing banal about the evil Witkin conjures up—and it does not stay on the canvas. He brings all the hurtling force of his abstract expressionist background to bear, attacking the narrative with a brush that is alternatingly savage and dance-like, particularly in the middle panels of this painting. The writhing gestures of the brushstrokes seem to swirl off the picture plane, insinuating themselves like serpents into our existence. Frenzied marks dart from graffitied walls to sulfurous floors, creating and disintegrating volume here, sinuous line there. The paint consumes as much as it describes, and we are sucked right into the maze.

Witkin's visits to a therapist during this period were opening up potent veins of memory and subconscious imagery. While *Subway* was taking shape, he was contemplating the scenes from his childhood that would result in *Division Street* (plate 13, and see chapter 2). At the same time, important breakthroughs were occurring in *Death as an Usher* (plate 6). One day, he asked the photographer Michael Recht, a fellow faculty member,

to take pictures of the central panel's running girl. Looking at the prints, he had a sudden revelation. "Take the running figure and just stamp it out, duplicate it," he scrawled in his journal. "The movement of her body must be the next gesture in a run—the seconds in time. She runs and doesn't stop—it's the inevitable! She must move to her moment. She sees herself dead; we see Death!" Later on he mused, "My mind is very occupied with trying to understand why 'actualness' is so important. By this I mean why is the fact (and presence in its most forceful appearance) so beautiful and moving. Caravaggio floods us with fact. This is causing me to respond more deeply and descriptively to how I draw and paint the figure. I need the thing painted to be more actual than life could ever present it. I also feel that I'm into a near-impossible feat with my triptych. I so need to do it. Will it work? Will it move figures and the observer? Will it be poetic, and present all I wish? Or will it compromise and get only close?"

An October 31 entry reads, "Hallowe'en. I've made the middle picture start having a wholeness, a magic. The dark gloss and orangish door helped. Tomorrow, November 1 (two years since the start of this triptych), I'm going to really *blue* her face."

A few pages later, under a list of new projects, headed by the tentative title *Myself & My Father* (which would later become *Division Street*), a triumphant circle surrounds the words "December 3, 1981: Finished the triptych!" And on the back inside cover of that year's notebook is the inscription, "To those who

helped me make the triptych: [models] Joanne Rella, Alex Rodinsky, Elaine Verstroot, Jane Collins, Robert Switolsky, Ann Crowley." Taking stock of this period of foment, Witkin wrote, "I draw best when I am really excited and *drawn* to it by surprise/mystery—and a certainty. No self-consciousness, only a rightness of control and feeling."

In January 1982 his new works were exhibited at Kraushaar. Despite the absence of the *New York Times* critic Hilton Kramer, he was exultant. "The show's over," he wrote on February 8. "I feel [it] was a moral victory! And a victory of friends, dealer, and [public] reaction. If I didn't have Hilton Kramer's blessing and prestige—well, I'd rather join stronger forces like Rodin, Caravaggio, Picasso, Giotto, Grünewald, Kollwitz, the Greeks. My works will last. Newspaper stock rots."

Vindication came with the April issue of *Art in America*. The critic Gerrit Henry wrote that Witkin's "subjects exist in a palpable state of existential extremity, and they are naturalistically rendered with lots of paint and feeling . . . *Death as an Usher* is, in the lexicon of contemporary realist painting, somewhere between history painting and Surrealism, and something decidedly new. Witkin obviously knows of what he paints. That he shares it with us is a simultaneous act of cruelty and generosity; we are given not simply the dumb frisson that might have been expected, but a human experience of the first magnitude."[2]

In the summer of 1982, Witkin moved from a loft he had divided and shared with other artists into his present studio at the Delavan Center. The new breadth of space allowed him to create stage sets in several parts of the studio, each set seemingly possessed by its own sinister forces. He had a three-walled, life-sized subway car built at one end; other works in progress had areas of their own. Now he was able to work simultaneously on several major canvases, a practice he continues to follow. Particularly when engrossed in scenes of physical and psychological trauma, he needs to turn toward the restorative yet no less demanding portrayal of the nude. For Witkin, the nude is not an object, not simply what Philip Pearlstein calls a "bodyscape," but rather a source for inventive, tenderly witty reflection on the relationship between artist and model.

While beginning *Subway: A Marriage*, Witkin was developing a pose for a reclining nude that seemed to possess a special potency; in his journal he refers to "the form and beauty" of the pose, to "the real and the ideal," and to his own experience at Skowhegan as a fifteen-year-old boy from Queens being confronted by a nude model for the first time. The painting using this pose took on its real identity when he invested it with a nightmare of being burned alive: by the summer of 1982 it had evolved into *This House on Fire* (fig. 12). "What began as a picture of an ideal woman's form (it became 'posed' and dull)," he wrote in his journal, "got to be a more present and convincing person sleeping (dreaming). I rediscovered that what we share in a work of art are our shared experiences, such as fear, dreams, pain, uncertainty, loss, etc."

Fig. 12. *This House on Fire*, 1983. Oil on canvas; 60 × 72 in. Courtesy of the artist

This House On Fire tells the story of a woman who has fallen asleep while reading the newspaper, and whose dream mirrors on a psychic level the very real conflagration in which she lies unsuspectingly. The deft brushwork, which depicts her glowing legs, shoulder, and head and the fragility of the newsprint, grows more gestural and more ethereal in its treatment of the smoke and flames that curl tenderly around the languid figure. At the lower right foreground, like an oven beneath her red-hot, recoiling hand, is a painting within the painting, the dream-image responsible for her "heat": a male nude, cropped to reveal only an arm, a leg, and a long penis, compressed in the incendiary dark rectangle like embers about to burst into flame.

Another important canvas of this period was *Roberta Braen: The Art Teacher* (1982–1983, 1985) (plate 9). The single panel is divided vertically into two parts as a spatial-temporal device. On the left is the artist's studio (the present); on the right, a stairway (a pathway to the subconscious, to memories or premonitions). Braen herself occupies both parts, arms akimbo as if gesturing toward these divergent realities. Her mouth is open in mid-sentence, one foot resting on the staircase that leads from her space to dream space.

Although ostensibly a standing portrait of a friend who taught art in one of the local high schools, the painting is as much about Witkin as it is about Braen. His first paintbox—the one he continues to feel ashamed of having won with stolen lottery tickets at St. Dominick's Art School—lies open in the left foreground, in front of a clock with no hands. In the right foreground, positioned as if to mount the staircase, is a sneaker. It is cropped too tightly for us to tell whether or not there is a foot inside. Tubes of paint, crayons, a palette, bits of paper are strewn about. The paintings and drawings tacked carelessly to the wall suggest the course of art history from the Renaissance through abstract expressionism. The warm colors of the foreground, echoing the figure's pants and vest, change abruptly once through the doorway. The yellow light of a metal studio lamp, illuminating an artist's paraphernalia, acts as a transition between the stairway in the room and the one that continues on through the dark, cool dream space lit by a small opening in the distance. The stairs themselves become monstrously high (inverting our perspectival expectations), and small ladders are set against them; a tiny figure is climbing through the opening toward a white light. One of Witkin's most mystical paintings, *Roberta Braen* is a tour de force of spontaneity and control, of solidity and evanescence. His skill as a draftsman, his sleight-of-hand illusionism, his rich color sense, and his gestural improvisation all coalesce in this canvas. "Art builds to something solitary and spiritual," he wrote apropos *Roberta Braen.*

Contemplating his ongoing work on *Subway: A Marriage* (plate 7), he noted the extent to which stills from films were an important influence: "The freezing of an action (of an emotion) caught on film and seen as a fragment (without meaning, as in not knowing the film's story) surprises one and this image can offer a wide and universal meaning. Simple reality becomes an apparition. It becomes haunted and haunting and at its best takes on its own life and destiny—something that can change you in a flash, as in the vision of St. Matthew. The picture is right when in the doing of it you melt away (disappear) in the best of the poetry you're leaving on that surface. I'm a picture-maker first—a director of a vital and lasting still-picture. I believe that there is a *universal* linking of experience (and the emotion of that experience). I work for that." And a few pages later he added, "I'm using the experiences of myself in this world to relate to others how it is to be alive in 1982—our fears, history, comedy, etc. This is painting as theater,

as cartoon, as song, as story. I don't care for art for artists and for the art-public."

Toward the end of the year, he wrote in his journal, "Our contemporary sacred event is to show how we are, how we live, how we hurt!" Turning to a dictionary, he copied, "Sacred = holy, cursed/to make sacred, to set apart for the service or worship of deity/devoted exclusively to one service or use (as of a person or purpose/worthy of religious veneration/holy/entitled to reverence." He added, "This definition *is* my work. The presentation of us in a way that stirs our compassion and sympathies. In being alive is our sacred comedy."

During the evolution of *Subway,* he began a series of small heads portraying subway passengers, using friends and people on the streets of Syracuse as models. "Seeing another's grimace— facial changes reflecting a mind-state—is an engaging and universal event," he wrote. Working on these heads, Witkin was reminded of the many hours he had spent in the subway each day going to and from classes at the High School of Music and Art, covertly studying the passengers around him (fig. 13).

Portraiture increasingly drew his attention, as studies related to polyptychs, as investigations into psychological states, and as commissions. During 1983 alone he painted more than a dozen such canvases, including a full-length portrayal of Jeff Davies (fig. 14), a Syracuse artist, and a large double portrait of James and Barbara Palmer, collectors and patrons of the arts (after whom the Palmer Museum of Art at Pennsylvania State University is named) (plate 11). And in the

process of exploring what he was then calling *The Wanting of Love* and *What a Boy Saw, Brooklyn, 1943* (later to become *Division Street*), he examined the nature of the self-portrait. Aiming, he wrote in his journal that summer, "toward a culminative self-portrait," he compared the investigation of self to pantomime, a "dramatic or dancing performance in which a story is told by expressive bodily or facial gestures, . . . a dumb show— signs or gestures without words."

His first self-portrait, *St. Isaac* (fig. 15), had been painted in 1970. From the vantage point of the present, the portrait of the artist as a young saint seems a postmodern work a decade ahead of its time. An intense young man in a striped shirt and bright red vest stares out at us. Around him all is in black-and-white— the black-and-white of the newspapers that flutter in the breeze and the black-and-white of art historical imagery, derived in part from textbooks, in part from dreams. A striking and formidably articulated painting, it is in the collection of the Galleria Uffizi in Florence, Italy.

Thirteen years later, Witkin was examining his own face again. Now it was not so much Witkin the artist as Witkin the man that he was searching out. *Four Faces at 44* was a working title in his notebook for what would eventually become a seven-paneled work called *Mind/Mirror: Suddenly Remembering an Insult* (plate 12).

The series begins with a self-satisfied grin, changes to a look of startled recognition, grows more worried and fearful, then enraged; it ends in a sliding together of two faces, one a mask of the other, that

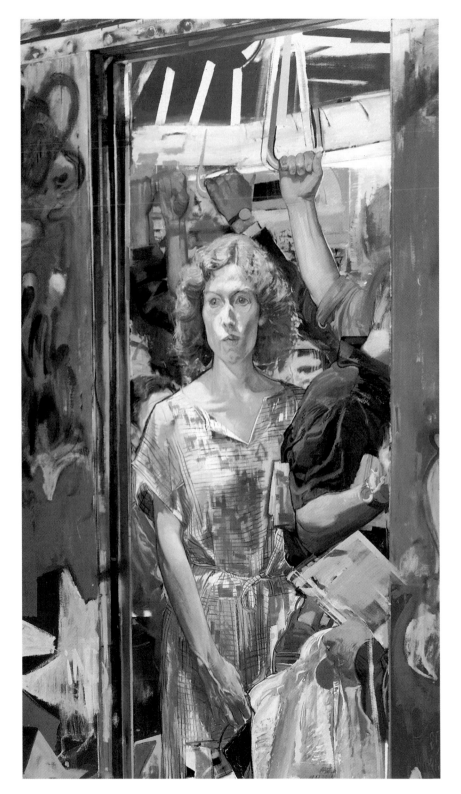

Fig. 13. *On the R & R,*
1985. Oil on canvas;
84 × 48 in. Collection
of the NYNEX Corpo-
ration, White Plains,
New York

Fig. 14. *Jeff Davies,* 1980. Oil on canvas; 72 × 48 in. Collection of the Palmer Museum of Art, Pennsylvania State University, University Park; gift of the American Academy and Institute of Arts and Letters (Hassam and Speicher Purchase Fund)

share a bulging eye echoing the sixth panel. The expression they share is one of horrified realization; it is the face of one who has faced at last both the nature of his own being and the vulnerability of life.

"Mirrors and doomsday," he wrote early in 1984, trying out themes and title. "Mirrors on thinking about a nuclear holocaust. Time in mind." By mid-June, he was calling the series his "Nuclear Self-Portrait," seeing it as seven panels ending with a mask that reflected "sudden, compulsive thoughts about doomsday." As he worked on the polyptych, the connection to nuclear devastation seemed less significant. "*Mirror/Mind* is really [about] an incident, an insult," he wrote on September 9 upon finishing the self-portrait, four days before his forty-fifth birthday.

During 1983 and 1984, Witkin completed several other self-portraits. *Self-Portrait, North Light,* a virtuoso performance in charcoal with seemingly unfathomable depths of chiaroscuro and a riveting presence, was acquired by the National Academy of Design. Another charcoal drawing of this period depicts the artist's face contorted in a manic grin. The painting *Inside, Outside* (fig. 16), in the collection of the Everson Museum of Art, uses the three-quarters-profile pose of *St. Isaac,* but here the figure is surrounded by masks. "The aspects of the Greek mask, fixed tragedy and the use of the face as a mask intrigue me, both as a symbol and as an entrance way to the truth in another person," Witkin told an interviewer.[3]

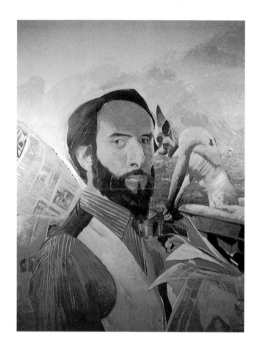

Looking at Mary Lawyer (fig. 17), a portrait of the artist and his model in the studio, is, like *Painter's Crossing: To the Passions of Rembrandt* (plate 2), a double image: we see the model and her reflection, the artist's gloved hand and his mirror image. From antiquity, artists have used models, but until recently, few works depicted the actual working relationship in the studio. The complexities of that relationship, exhaustively explored by Picasso in his later years, continue to be fertile territory for Witkin (as well as for such artists as William Beckman, James McGarrell, Marcia Marcus, Gregory Gillespie, Sylvia Sleigh, and Paul Georges). He has continued to paint the artist and model in the studio in works like *Are You Here? Sue Ades Posing* (1985), *Breaking the Pose (The Art Class)* (1986), and *See What I Mean? Let's Try that Pose* (1989). Although for most painters the

Fig. 16. *Inside, Outside,* 1984. Oil on canvas; 60 × 48 in. Collection of the Everson Museum of Art, Syracuse, New York; gift of the American Academy and Institute of Arts and Letters (Hassam and Speicher Purchase Fund)

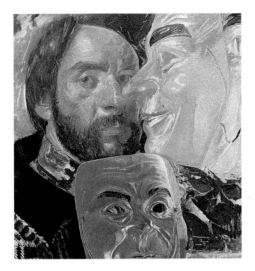

studio pose lacks narrative content, for Witkin there is a story in every gesture, and the model must be capable of investing the physical with the psychological. "I want charged emotions," he says. "The mind and the body have to be involved. Unless you know what you want to do, what role the model will play, you're likely to get a meandering confusion, subject to the mood swings of both parties. The model has to link in with you in a collaboration of presence" (fig. 18).

By the end of 1984, Witkin had completed yet another large portrait, this one of Thalia Cohen, an active participant in the Syracuse art world (fig. 19); had executed a series of fifteen drawings depicting the final three days of the trial of the Griffis Plowshares Seven, a group accused of damaging a bomber and other military equipment at Griffis Air Force Base in Rome, New York; and had made important strides toward the completion of *Division Street.*

Of the Plowshares Seven, Witkin told me at the time, "I wanted to observe these people. They're as obsessed by their mis-

sion as I am by my work." He had been following the civil disobedience actions of radical Catholics for several years. Thoroughly caught up by the unfolding drama at the Federal Building in Syracuse, he found "a holy quality" in the proceedings. "The defendants presented themselves with quiet dignity. And yet, as a visual artist who works in symbols, I was very aware that they were creating a happening, a theater of activism for which no one had rehearsed. These people are on the front lines. The rest of us hide behind our newspapers." His admiration for the defendants—Dean Hammer, Elizabeth McAlister, Karl Smith, Vern Rossman, Jacqueline Allen, Clare Grady, and Kathleen Rumpf, all of whom were sentenced to terms in federal prisons— would lead in the following year to paintings featuring a priest and a nun: *Mortal Sin: In the Confession of J. Robert Oppenheimer* (plate 14) and *A Nun's Decision* (plate 15). The drawings he produced during the three days spent at the Federal Building have an unrefined, naked quality that mirrors the simplicity and vulnerability of the Plowshares Seven. Expressions and nuances of body language are caught in quick, deft strokes of graphite. Large areas of empty space become dramatic elements in themselves; gentle arcs and sweeping diagonals are countered by lively, seismographic lines.

Continuing his work on *Division Street,* Witkin analyzed the emotional intensity of the remembered scene. "It's a separate anger, hers and his," he reflected in his journal as he mapped out his mother's frustration and his father's leave-taking. "How does the eye and mind take in the

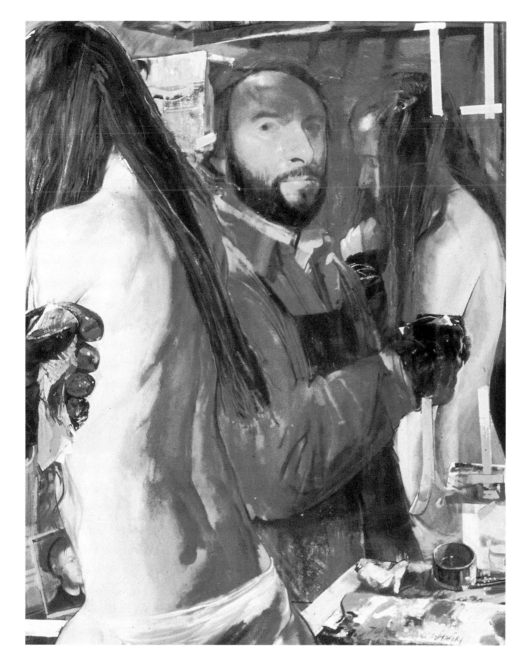

Fig. 17. *Looking at Mary Lawyer,* 1979–1980. Oil on canvas; 60 1/4 × 48 in. The private collection of the University of California at Berkeley; Berkeley, California. Gift of Paul Thiebaud

emotion?" He had his model Francine Stuart Horton repeatedly hurl plates of spaghetti and sauce at the wall until he caught just the right trajectory of crockery and splattered food. To convey the high pitch of emotional intensity, in all three panels he compressed the space in which the action takes place, creating an atmosphere in which the viewer, like the boy witnessing the scene, cannot possibly escape.

"The use of a telephoto [can] 'crush' the form to help express the boy's

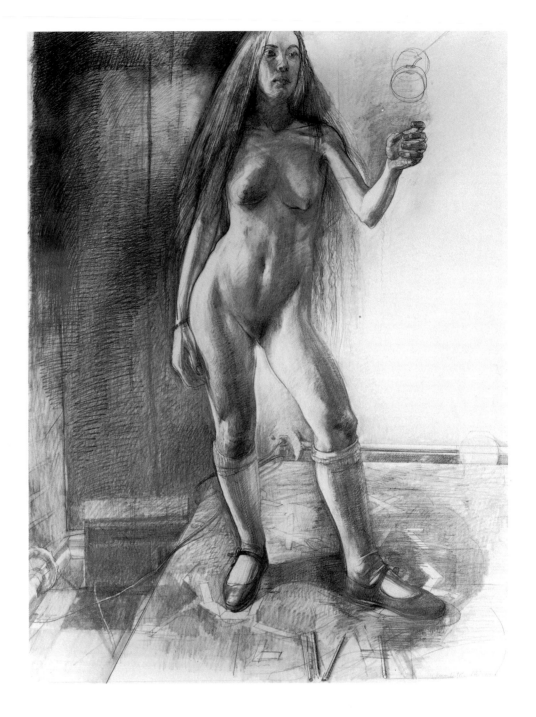

Fig. 18. *Eve*, 1983.
Graphite on paper;
72 × 42 in. Courtesy
of the artist

emotional take on the scene, his surprise and shock," he wrote. "This is a visual-expressive space, not a cubist-oriented German-expressionist space."

The triptych was finished by May 21, 1985: "a psychiatric autopsy of a trauma," Witkin jotted in his journal.

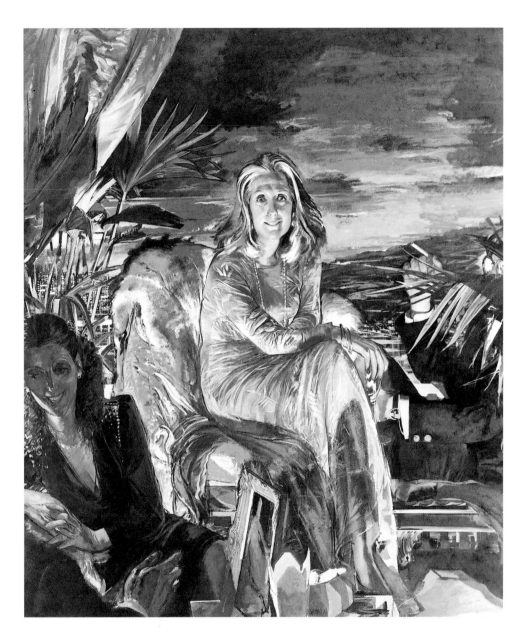

Fig. 19. *Thalia Cohen*, 1984–1985. Oil on canvas; 75 × 63 in. Collection of the Delaware Art Museum, Wilmington (F.V. du Pont Accessions Fund)

IV ❧ AVATARS IN DARK CORNERS

THE MAN in the white lab coat kneeling in the confessional exudes tension, from his claw-like hands to his clenched neck and jaw. One hand clutches at his rigid jaw, as if prying his mouth open. We all but hear his scream of self-accusation. The finger of his other hand jabs at his heart.

Behind the dark, lustrous wainscoting of the booth's interior, a section of his laboratory is revealed. The precisely aligned verticals of the light-etched table legs and the white jacket hanging from a hook echo the lines of the wainscoting. A beam of light pours in from an unseen source on high, enveloping the kneeling figure and a corner of his work table in a cold, unforgiving glare. An eerie blue light, coming from behind the window of the booth, plays over the scientist's face and body. On the table and floor lie scraps of white paper and jottings on yellow sheets—suggestive of the ones Enrico Fermi dropped to test the shock wave of the atomic bomb[1]—and, incongruously, a folded paper airplane—shaped and flown, perhaps, during an earlier moment of scientific contempla-

tion. This image is a loaded one in the context of the aerial devastation of Hiroshima and Nagasaki. On the rear wall is a blackboard covered with a partially erased skein of formulae. Witkin, an inveterate punster, allows us to decipher *sin,* the abbreviation for the trigonometric symbol *sine,* among the letters and numbers scrawled on the board.

Thus unfolds the left half of the 1985 diptych called *Mortal Sin: In the Confession of J. Robert Oppenheimer* (plate 14). On the right is a scene of postnuclear devastation. The blue light irradiates a swath of darkness across the other side of the wainscoted booth, which here is cracked and peeling, and ends in a tumble of objects—broken crockery, shoes, cans, torn clothing—and a general state of structural decomposition. A chalky film has settled over everything: radiation dust. Emerging incorporeally, his brown robe virtually indistinguishable from the dark wall behind him, is the seated figure of a priest. His face bears the scars of a burn victim; his arms end in prosthetic devices. In marked contrast to the scientist and his charged body lan-

guage, the priest sits quietly, receptively, patiently. Despite his disfigurement (brought about, we are led to realize, by the brilliant discoveries of the very one to whom he listens), he exhibits no trace of anger. As in the first panel, sheets of yellow paper are scattered at his feet; here, they are burned beyond legibility. A single piece of paper, white, remains intact; on it, we read the title of the painting.

The diptych format of this work splits the composition vertically, severing science and religion, the analytic and the metaphysical, the active and the passive. This is a split that results in a world gone awry, a world in which humankind has lost the grace of the human spirit. The boundary between these dualities is thick and uncompromising. It is very different from Witkin's exploration of the borderline between dream and illusion in his other paintings, in which he has revealed it to be ever-shifting and insubstantial, a fundamental illusion. Yet there is dialogue across this borderline: the scientist screams out his confession; the priest listens with wordless compassion. And visually, the figures and the echoing shapes behind them lean toward each other, forming a nearly perfect, although bisected, isosceles triangle: the Trinity.

As he did with his preparations for *The Devil as a Tailor* (plate 3) and *Death as an Usher: Germany, 1933* (plate 6), Witkin immersed himself in his subject. "I got so involved in Oppenheimer's diaries I reached a saturation point," he recalls. On the occasion of the first test at Alamogordo, Oppenheimer had written, "I remembered the line from the Hindu scripture, the *Bhagavad-Gita:* Vishnu is

trying to persuade the Prince that he should do his duty and to impress him he takes on his multiarmed form and says, 'Now I am become Death, the destroyer of worlds.' I suppose we all thought that, one way or another."[2]

The more Witkin read, the more filled with aversion he became. "Has science been good to us? It's been as perverted as anything could be. The two moments of greatest impact on our time have been the Holocaust and the dropping of the atomic bomb. They have changed our lives by reducing our self-respect. Our capacity for feeling has been reduced in the wake of such horror. And so we see a prostitution of values, in art as in everything else."

In portraying the imagined confrontation of the inventor of the atomic bomb with a priest who has survived a nuclear attack, he worked more than ever before in a collaborative fashion with his models. Bob Bersani (fig. 20), a friend of Witkin's who had been severely burned in a car accident, posed as the priest. "I could have imagined his face, or used a photograph of a burn victim, but I wouldn't have felt the dialogue between the model and myself. The impressionists said you have to look at things; you can't just work by some predictable formula. I painted him as factually as possible."

Placing Oppenheimer, a German Jew, in a Catholic confessional had a perverse logic for Witkin, reflecting his own Christian-Jewish religious background with its mixture of indoctrination, doubt, and inner searching. "The model posing as Oppenheimer hated the idea of

Fig. 20. *Bob Bersani,* 1986. Oil on canvas; 24 × 20 in. Collection of Pamela and Joseph Bonino, San Francisco, California

kneeling at first, but eventually he really got into it," Witkin says. "He was embarrassed at the idea of spilling his guts. How does one confront the person one is feeling guilty about?" *Mortal Sin* is that private confession made public. In its very particularity, it represents the universal. Viewing this painting, we are forced to confront our own fallibility. Our acts may not compare with the setting loose of the nuclear genie, but they have their own consequences.

How does an artist represent a reality too terrible to contemplate, an image no one wants to see? "The risk of looking into dark corners is you learn from it," Witkin says. "The more you're in the dark, the more you see what's in there. You find out it's not so different from what's outside—just more intense."

While working on *Mortal Sin,* Witkin found himself drawn to the work of Goya. "He was really the first modern artist, modern in the sense of conveying anxiety. He was in his fifties when he began doing political allegories depicting his time. His early work was decorative; then he got into psychological portraiture. The last period of his life was devoted to investigating the minds and deeds of his contemporaries."

When Witkin saw the back page of the May 30, 1985, issue of the *New York Times,* which contained a speech given by President Dwight Eisenhower before the American Society of Newspaper Editors on April 16, 1953, he immediately clipped it and posted it on his studio wall. "Every gun that is made, every warship launched, every rocket fired signifies, in the final sense, a theft from those who hunger and are not fed, those who are cold and are not clothed," Eisenhower had told the editors. "This world in arms is not spending money alone. It is spending the sweat of its laborers, the genius of its scientists, the hopes of its children. . . . This is not a way of life at all in any true sense. Under the cloud of threatening war, it is humanity hanging from a cross of iron." Eisenhower's theme seemed particularly appropriate as the artist contemplated the grim power of Goya's *Disasters of War* and

the equally grim reports from Amnesty International of political prisoners being tortured and civilians being caught in warfare on nearly every continent.

In the mid-eighties, with neo-expressionists commanding the art establishment, neoconservatives entrenched in the White House, and fundamentalist preachers darting from television pulpits to political fundraisers, Witkin began two paintings that were sharp commentaries on contemporary society. Accounts of brutality suffered by political dissidents in Latin America triggered the creation of the six-and-one-half-foot-long, single-panel canvas *Unseen and Unheard (In Memory of All Victims of Torture)* (plate 17); and several months before the Jim Bakker scandal erupted, Witkin started work on the thirty-five-foot-long polyptych *A Jesus for Our Time,* tracing a young man's religious awakening, attainment of power, confrontation with violence, disillusionment, and despair.

Although the scene depicted in *Unseen and Unheard* has an international relevance, the painter located it in his own mind in a Guatemala City police barracks. Called "a blatant *tour-de-force* on man's brutality to man, any time, anywhere, . . . a contemporary cautionary tale, a fable fated for tomorrow's headlines" by the art critic Gerrit Henry,[3] the canvas seethes with the unmediated truth of suffering.

"We live in a world in which we must choose between being a victim or an executioner, and nothing else," Witkin wrote in his journal early in the course of the painting's development. "Such a choice is not easy! So many men are deprived of grace," he added, paraphrasing Albert Camus. "How can one live without grace? One has to try and do what Christianity never did, that is, be concerned with the damned."

In the fall of 1985, he spent several days at University Hospital drawing cadavers. The repeated sketches of bodies stiff with rigor mortis gave him what he needed for the pain-wracked rigidity of the figure in *Unseen and Unheard;* the composition was influenced by the fifteenth-century *Pietà d'Avignon* at the Louvre, in which Christ's body forms an unyielding arc across Mary's knees. In his notebook, small drawings show the development from the inert, deadweight figures of cadavers to the contorted curve of the torture victim, whose right wrist is bound with leather to a metal cot in the painting.

Unseen and Unheard is unbearably graphic. An electric wire leads from a transformer on the floor, beneath the metal grid of the cot, to a metal prod that has been inserted into the prisoner's anus. His left arm is a vibrating blur; his face, turned away, is anonymous. All we see is the mouth, wide-open, screaming. A radio-tape deck blares in the foreground; on it is a half-eaten banana. The juxtaposition of hideous cruelty with the banal details of ordinary life intensifies the shock for the viewer.

Behind the cot a vest, a jacket, and an ammunition belt are slung on hangers and hooks, and the yellow handle of a mop leans against the wall like an

extension of the electric prod. Off in the corner is the torturer. He is answering the telephone, one hand covering his ear so that he can hear through the inconvenient shrieks of his victim. His bulging form, clothed in the daily khakis of a military functionary, is in sharp contrast to the emaciated and naked figure of the man on the cot.

Witkin's palette in this painting is quite unlike that used in any of his other works, although the yellow mop handle is recognizable from *Division Street* (plate 13). A neon pinkish red emanates from the transformer, sizzles along the electric prod, bathes the underside of the victim, and highlights the torturer's face and body and the wall behind him. Deep greens and hallucinogenic blues shimmer in the shadows. "I glazed for brilliance, and wow!" Witkin jotted in his notebook. "I used the Polaroid colors to make the scene more theatrical and rich in shadow and deep in color."

On February 10, 1986, Witkin wrote, "A real [feeling of] low and doubt has set in. Confusion and a loss of interest in home and studio. What is this odd time about? A burn-out? A recharge of batteries? Perhaps it is what a new phase feels like: blank page, and then a new chapter? I feel the care of 46 years now, and I feel more fragile and more the fool. Am I doing anything? Be positive. Continue—get through it! And finish the torture picture—get *that* done!"

He added, "Love and its folly; its nonbeing hurts me. Yet this is what I want to paint about. The wanting of love, the giving of it. Love as healer. Without it, one dries up. Oh, God, help me to go on. So

much welling up of unclear feelings!" A week later, he wrote, "A great day for the torture painting—it really has an atmosphere now, and the color clicks!" And on February 23, it was finished.

That spring, Witkin began the lyrical and compositionally complex *Breaking the Pose (The Art Class)* (plate 18), of which he wrote, "the idea of the moment of release from one [staged] pose to a natural pose is critical to the work." Like the 1985 canvas *Are You Here? (Sue Ades Posing)* (plate 16), with its studio setting, its interrupted moment between artist and model, *Breaking the Pose* was as important to Witkin's mental health as it was to his oeuvre. After months spent with cadavers and images of torture, it was rejuvenating to focus on the classical forms of the nude female model in the studio, surrounded by soft draperies and the phallic thrusts of easel and brush.

Unlike *Are You Here? (Sue Ades Posing)*, which focuses on one primary and one subsidiary figure, *Breaking the Pose* is a many-layered work in which figures are paired and echoed. Not only is there a double pose, but the young male student is reflected as well in a mirror that also reflects his canvas, so that we see the central model, whose back is toward us and the student, twice. As in *Are You Here?*, the artist's hands project from one corner, a metaphorical self-portrait; the sharp vertical line of easel and canvas is in counterpoint to the flowing cloth, the luxuriant curves of hips and breasts, shoulders and thighs.

Although seen from behind, even the pose of the blond-haired figure in *Breaking the Pose* is similar to the one in *Are*

You Here?—the model is leaning one elbow on the back of a chair, turning sharply in response to the interruption of the pose, body and head twisting to accentuate the lyrical passages where hip meets waist, neck meets jaw.

Both canvases have a clarity of focus and a seemingly casual yet elegant arrangement of forms that heighten their sensuality. In *Are You Here?* the squares of the quilt on the platform are repeated in the rectangles of cloth and canvas in the background. An art book—the weight of art history—lies open at the model's foot; her toe points neatly toward the binding. In *Breaking the Pose* the space is deeper, more intricate, but the cascade of figures from upper left to lower right and back up again in the distant reflection is as stately and as classical as a Mozart serenade.

Even though much of Witkin's oeuvre is dedicated to social commentary, the conceptual is always subordinate to the tangible. The narrative must be given the force of actuality. Whether the tale is one of high tension, as in *Unseen and Unheard,* or a simple moment in the studio, as in *Are You Here?, Breaking the Pose,* and a related painting, *Tit for Tat* (plate 10), the model and the specific environment are essential components. Without seeing, for Witkin, there is no believing. "I must see the figure in an atmosphere that moves me," he says. A notebook entry reads, "Do I lack the strength of a Beckmann, Guston, Picasso to just make it up? Why do I and Degas, Caravaggio and Rubens, etc. need models? I do, that's all!"

Contrasting his work with the emotionally detached paintings of models in the studio by contemporary figurative artists who avoid literary content, he wrote, "I want to create people who are seen during crises. Paintings of the human form with chairs and rugs are finally just boring. To say they are 'well done' could be a description of how you want your meat. Such detached depictions of people in this age of crisis is absurd! As in the theater and film, each human being has a story to tell. What is the relationship to life and the oldest theme, which is, how we live and how well or badly we behave in our lifetime? A narrative artist must find a way to present telling moments that we all can relate to in a telling way. The power of the human gesture is profound!

"As a narrative figurative painter, the questions I ask are, how does one depict a memory, a dream, a traumatic event? How can light and color deepen the image? Is a single painting enough to propel the movement and the time, or must we consider a scroll format of 20 feet or more, to provide the sequential element found in film and comic books? Do we need to think in terms of zoom lenses, close-up devices that are the visual currency of our time? Your mailman and your mother can read and understand my paintings. I want that!"

By mid-summer of 1986, his journal was filled with sketches for *A Jesus for Our Time* (plate 19), which at first he had titled *A Jesus for Non-Believers,* and later, *The Second Coming, Beirut, 1984.* The issues he wanted to examine in this major polyptych were, he wrote, "the sense of struggle; a mythic hero who is . . . beaten down by the world, yet still believing in a

guide." He envisioned one panel that, in good altarpiece tradition, would be taller than the flanking canvases; that panel would portray an evangelist at the high point of his fanaticism, not on a television set in America, but in a glass box in Beirut.

The narrative was clear to Witkin from the start. The protagonist, Jimmy Jesup (the name, of course, a variation on Jesus) would first be in his miserable hotel room, surrounded by Christian symbols (fig. 21). Next, he would preach in Beirut, an epicenter of religious fervor and violence. Then a car-bomb would explode, crashing through his protective glass box. His fragile hold on reality would fracture along with the glass. At the end he would be back in his hotel room, abandoned by his faith and mired in degeneracy. The sequence of the five panels would move from awe to fire and brimstone, shock, mental breakdown, and despair. By the spring of the following year, Witkin's sketches had developed into a thirty-five-foot-long painting in progress, a painting that more than any other of his works to date employs sequential imagery to portray not only events through time, but the spiritual, emotional, and psychological changes of a single human being.

"More and more I'm aware of the importance of the figure," he told me as he worked on the five canvases. "The times are too desperate to have an art that avoids life and world problems." Asked what triggered *A Jesus for Our Time,* he replied, "A little Rembrandt etching. I wondered if I were to make a picture of

Christ and his life how I would do it. I've always been intrigued by the idea that Jesus didn't die, and that his twin brother died in his place, and he continued as a man, with real-life problems. I wanted to make a real-man Jesus, somebody who is stripped by life and has to come down to earth. The attempt to make something so loaded is really a challenge. In these times, a lot of people would like to see a redeemer, a savior, some superman or charmed avatar who could stop the craziness. Someone other than the politicians. My savior becomes a failed avatar. He's fragile; he thinks he can heal the world through spiritual means, but he's not up to the task.

"There's no real church art in our century; heroes are hard to find. One of my favorite movies is *The Day the Earth Stood Still.* It's Icarus's fall that makes the drama. People set themselves up when they construct their own conceit. . . it's the torment of the journey, the pleasure and pain of art and love that makes the painting. . . . I'm making a comic strip with uncomic implications."

Time and place are explicit in *A Jesus for Our Time.* The first panel, *The Use of the Suit,* takes place at dawn, in the fall, in a dismal hotel room in a small town somewhere in the midwest. An open notebook on a cardboard box in the foreground allows us to read the text: "On Nov. 1, 1971, Jim Jesup was commanded by God to heal a hurting world and while doing good he would become a Jesus for our time." The next few pages curve toward us, so that we can read further along, "Sixteen years later Jimmy Je-

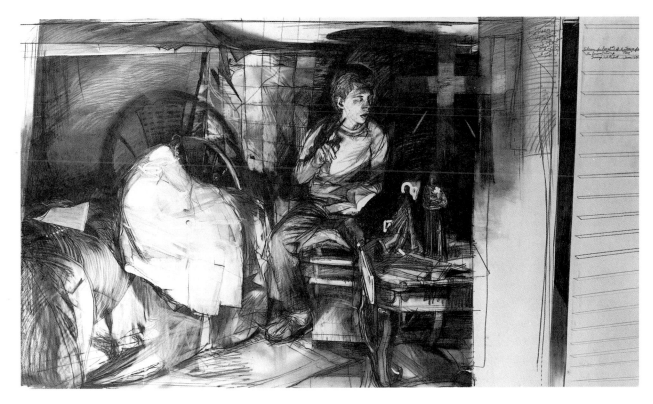

sup entered the sad and beleaguered city of Beirut."

Jimmy is seated on a chair next to his rumpled bed, surrounded by open Bibles, a closed book on Satanism, a picture of Jesus. Lying across his lap and supported in his arms like a disembodied pietà is a white sharkskin suit. His sweet, upturned face is turned toward the right of the canvas, where a succession of visionary images are occurring: a yellow winged form (a bird? a tiny trumpeting angel?), a bright white cross, and a smaller cross in front of which is Jimmy himself, dressed in the white suit, arms outstretched.

"I'd like to make this painting silent and cause the thought of a presence," Witkin wrote in his notebook while working on the piece. "I want it to be quiet, more profound in its silence; a religious experience, conveying the spiritual and the vision, the rapture."

We are voyeurs here. Everything is revealed through a window streaked with dirt and the red-violet tones of sunrise. We can make out the reflection of a neon sign, "Bar," and a ghostly locomotive. The yellow wooden crossbars of the window lead horizontally toward the yellow police lines of the next panel, *Jimmy's Mission to Beirut (Late Afternoon)*.

In the second canvas we find the rosy colors of the brick wall and reflected sunrise repeated in the sea of heads and upraised arms in front of Jimmy the preacher in his glass box—the box that at once protects and isolates him from any

Fig. 21. *The Presentation of Jimmy's White Suit* (schema for Panel I of *A Jesus for Our Time*), 1987. Charcoal on paper; 48 × 84 in. Courtesy of the artist

human touch—and in the complex blur of burning buildings mirrored in the glass behind him. Small yellow ladders, stairways, grids of apartment buildings surround the figure in white and the white cross against which he stands, one hand gripping his Bible, the other jabbing a finger in a gesture of pious indignation. His face, so innocent in the first panel, is twisted into a self-righteous grimace. Accentuating the triangular composition, three metal microphones lead the eye toward the glass box like a row of missiles. Behind them are blue street signs in Arabic. Projecting into the painting from the edge of the canvas is a hand holding what appears to be a weapon—perhaps a long, slender-barreled pistol—pointing directly at the preacher.

A repeated motif is the circle: metal disks, floodlamps, a wristwatch, sunglasses, camera knobs and lenses, and targets. One distant circle could be yet another floodlamp or the thinly etched outline of the moon's full shape barely visible above its silver crescent hanging in the smoky late-afternoon sky. At the lower left corner is a yellow diagonal of tape marked (in English, despite this being Beirut—Jimmy is, after all, a thoroughly American phenomenon) "Security Line Do Not Cross." The yellow line is repeated higher up, slicing across the glass-enclosed figure at the knees. The yellow line is also a pictorial device used to link the five canvases much the way the palette and the sharp thrust of movement throughout the polyptych do. It leads the eye in a nearly unbroken line from the first panel's yellow window frame to the security tape in the second and the yellow slashes of reflected flame in the third; from the long stretch of security tape in the fourth, it comes home in the final panel's hotel window.

The Explosion of the Car Bomb is the equivalent of the second panel in its complexity, but here the pictorial space is shattered by flying fragments of the objects from the previous scene. Bibles, a spotlight, a shoe, papers, sections of the wooden frame from the glass box, and shards of glass mirroring the chaos and destruction embodied in this moment—all are shooting past, as the figure of Jimmy Jesup, looking over his shoulder toward the next panel, kneels in bewilderment and fear. The sharply etched white cross has lost its rectitude; it is now bent, leaning like a hooded Ku Klux Klan figure over the preacher. The sunrise colors of the first panel, repeated here, also serve to reflect the flames from the next panel, *His Agony and Crack-up,* in which a dark stone wall and the charred remains of the car, still in flames, with a huge chunk of a building that has fallen onto its roof, form a sinister backdrop for another visitation—this one of a secular kind.

A young woman in white with Red Cross insignia on her sleeve holds Jimmy in a way that restrains and calms him. As in the second panel, the composition builds to a triangle, with its inherent religious implications; yet here, we find something strangely erotic in her pose, with the red-gold reflection of the flames tracing her legs and buttocks and her right knee shoved between the preacher's hip and calf. A bit of flame laps at one of

the preacher's knees; at the other, directly in line with his shell-shocked gaze, are an anonymous pair of burned and bloody feet, sliced by the yellow tape.

The perspective is isometric; everything is on a tilt, much like one of Cézanne's tables. The edge of yellow on the nurse's back is almost on the same plane with the yellow-orange on Jimmy's jacket. The pale yellow rectangle of flame in the background works according to a simple optical truth: we see cool before we see warm. The painting reads back to front, in a Hans Hofmannesque push/pull of formal elements; the yellow diagonal of the security line tape leads us back out of the painting and toward the final panel.

Remembering the Fire; Jimmy's Back Home is a scene of moral and spiritual degradation, of hopelessness and torpor. In his squalid hotel room, which is far messier than in the first scene, Jimmy sprawls on his wooden chair, a cigarette dangling from one hand, his other resting on a table littered with empty liquor bottles. What were crosses in the first panel are now just a white vertical slit of light from a bathroom door and an arrow pointing to a girlie pinup; yellow streaks rain down the windowpanes like tears, the watery counterpart of the remembered flames. The notebook with its prophecy lies in the trash together with another empty bottle. In the background are the barest suggestions of images from previous panels: a car, small yellow ladders. The bar sign, white in the first panel, is now lit up; darkness has fallen and the room is bathed in a lurid neon glow.

Witkin's approach in the creation of *A Jesus for Our Time* was to leave sections of each canvas unfinished and to move from one to the other, using the same palette in his orchestration of the various formal and narrative devices. Some elements that were strong at the beginning stages of a panel were later modulated, so that just a hint remained as a link to similar elements in the other panels. A delicate, powdery blue on an arm or elbow in *Jimmy's Mission to Beirut (Late Afternoon)*, for example, is used more vividly in the sky and smoke of that painting; in the trousers, the outline of the crosses, and the reflections of *The Use of the Suit*; in the flying glass, the cross, and the evangelist's suit in *The Explosion of the Car Bomb*; and in the figures of *His Agony and Crack-up*. A single vertical mark above the figure is all that remains of that blue—the barest echo—in *Remembering the Fire: Jimmy's Back Home*. There is a contrapuntal movement from right to left and then back again in the colors and forms that course through all five panels.

As he worked, Witkin was reminded of a transformative experience many years earlier. "While at the Boston Museum of Fine Arts, I stumbled into the oriental wing, and found myself in front of a famous scroll called *The Burning of Senju Palace*, about a samurai invasion. The way the whole thing moved through time blew me away. A few weeks afterward, I saw Teinosuke Kinugasa's 1954 film *The Gate of Hell*, which seemed to reproduce scenes from that painting. The great tapestries, Leonardo's battle pictures, Michelangelo's *Last Judgment*,

and Rubens' vast panoramas have the same quality of organized and choreographed chaos. I'm not in a culture that uses scrolls, so I have to look to films, comics, the pages of books; I have to break the whole into segments as a means of making time and space jump."

Much is going on in *A Jesus for Our Time,* but unlike the precision of pictorial details in Chinese and Japanese scroll paintings, here the individual elements seem to shift and blur before we can identify them. A Bob Dylan song comes to mind: "Something is happening, but you don't know what it is, do you, Mr. Jones?" The painting carries us in and out, up and down and across its many visual levels; as in reading the fiction of Borges, we understand but we cannot always explain. Yet as the eye travels back and forth across the five sections, the power and the meaning hit home.

"I've never used every trick in the book like this before," the artist said during the final weeks of *A Jesus for Our Time.* "I don't even know my style by this time. I'm just doing it. I've painted with tubes right on the canvas, with my fingers. I've let go of the brushes and just smeared the pigment on; I've scraped entire passages out, left others unfinished, gone back into others until nothing remained. The yellow rain of number five came after I had gone to the bank one morning and had turned the windshield wipers off; I sat there drowning in the waters of forgetfulness, and then I realized, that's it."

While working on the polyptych, Witkin painted two related canvases, *Suddenly* (fig. 22) (a version of *The Use of the Suit*) and *Self-Portrait with a Jesus for Our Time* (plate 20) (with the artist's face reflected in the glass enclosure used in *Jimmy's Mission to Beirut*). He also produced five large drawings and twenty-five small sketches. Throughout he was inspired by the dramatic ability of his model, Wayne Pond, who was capable of embodying sweet innocence, fiendish fanaticism, fear, anguish, and degeneracy from one pose to another, and by the mute eloquence of Justine Fenu, a mime in real life, who played the nurse.

With *A Jesus for Our Time* finally completed, Witkin's elation was tempered by irony: "This painting is totally unsaleable. Who's going to buy it? Maybe the Atheist Museum! What I have attempted to do here, and what contemporary figurative painting is all about, is to be true to how people live; to take ordinary life and paint it extraordinarily well. I've ended with an edge of doubt, but I think the doubt makes it better. If the artist were certain, he or she wouldn't make art. Religious belief can so easily become restrictive.

"The artist and the poet must admit to their nakedness. It's come as you are. Otherwise, there wouldn't be the searching, the desire to know something beyond oneself. What do I really believe in? I know having the ability to make art is something given, maybe something divine. The arrival of a picture has an importance beyond my imagination, my fantasies. Being an artist is, in a way, being a channel. Yet how do we approach God? I really think a lot about how others will see this; I want it to be as human as possible. People are talking about get-

Fig. 22. *Suddenly*, 1987. Oil on canvas; 69 × 77 in. Collection of the NYNEX Corporation, White Plains, New York

ting out of the fundamentalist bubble. Maybe this painting can cause some doubt about the use of religion as a ploy to take people away from real life. The purpose of art is restorative. I think even with a down ending like this, the viewer's compassion is aroused; compassionate acts can come of it."

On August 10, 1988, he wrote in his journal, "Having seen tonight Bill Moyers' 'God and Politics,' I'm convinced my *Jesus for Our Time* is prophetic of the coming Fascist-Right-Wing Bible jerks who will *demand* a simplistic march to the sea in lock-step of bigotry and mindlessness. . . . The Baptists fear the word

humanism because it smacks of the freedom to discover and think for each individual. We *are* God, so why must we believe in Ol' Pappy and paternalism? Each of us enters the long road alone; our internal gods will guide us. This is the wonder of our differences—to find ourselves outside of group-think. Why do we, in this *rare* democracy, not honor our blessed Constitution and all our freedoms?"

After completing *A Jesus for Our Time*, Witkin worked simultaneously on several projects. Among them was the nine-foot-long polyptych *Benny La Terre* (plate 22) (for a while tentatively titled

The Wanting of Love). In 1985 he had begun sketching out ideas for this painting, which he described in his journal of that year as "a lonely man flooded by eroticism," and in a later notebook, as a painting about isolation.

The inspiration for the figure was a young Greek boy from his childhood. Benny, who was brain-damaged, was a fellow Boy Scout; Jerry was appointed his caretaker. "I was always wiping his ass," Witkin recalls. "I remember feeling cheated out of the chance to be with the other guys. I had a kind of enforced servitude to this victim. Now I can't even remember his face. In the painting, he's the outsider grown up. He's the modern-day untouchable, perhaps an AIDS victim."

Benny La Terre represents three simultaneous realities. All we see are the backs of these similarly positioned figures: first a pock-marked statue, then a man suffering from a gruesome skin disease (Kaposi's sarcoma is implied), and finally a leather-jacketed subway rider, to the right of whom two cropped figures stand crotch-to-crotch, the hands of one on the rump of the other. It is hard not to view the middle panel as a cautionary tale for the third panel's intimations of casual sex. The horrendously pustulating barebacked figure sits on rumpled bedclothes (painted with a paradoxically Vermeer-like delicacy) that extend across the bottom strip into the foreground of the first and third panels.

The three sections function as sequential windows of the subway car depicted in the third. The dead-white plaster tones of the first and the harsh subway-car green of the third are brought into

the middle canvas and frame the figure, on the left as a black-and-white photograph of which all we can read is a hand clasping an arm, and on the right as a draped fabric. The panels are set into a textured frame that positions the first and second close together and leaves more space between the second and third. This not only sets the third apart but simulates the locomotion of the subway train, hurtling forward and then lurching to a brief stop.

The backs in the first two panels bear clear art historical references: the middle one to Ingres' bathers, the sculpture to Canova's *Three Graces*. Looking through an old *ARTnews* annual, Witkin had seen a photograph of this sculpture showing the rows of nail holes resulting from the process of translating the work from plaster into marble. The nail holes immediately suggested diseased skin. "A picture gave me the picture," he says.

During the same period in which he produced *Benny La Terre* (1987–1988), Witkin painted *Saint Joan* (fig. 23) and *Her Dream* (plate 21). Although a single canvas, the temporal and spatial complexity in *Her Dream* are consistent with the artist's approach to his polyptychs. Here he paints two pictures in one panel; the unconscious is portrayed in the midst of the tangible world. The movement is not from left to right, but from front to back; not from past to present, but (as in *This House on Fire*) within a simultaneity of dream and reality. The figure, her head (consciousness) toward the viewer, seems to be hurtling downward like Alice in the rabbit hole. Her pose and the opened letter that has fallen in the

60

foreground suggest a message potent enough to cause a swoon or an overwhelming reverie. Bathed in light, her heavy limbs are lushly painted in warm pinks edged by eerie greens that lead the eye into the inchoate room she lies in, with its distant, partly veiled window, its mix of solid and phantasmagoric objects. Close upon her, lending a note of necrophilia, is a skeleton. The two long, dry bones that form a *V* over her body mimic the lines of her vibrant thigh and shin. At the right foreground is yet another painting within the painting: this one smaller, of a photograph. Is the soldier who looks out from the frame her lover? the writer of the letter? her dead husband or father or brother? We cannot know the specific story—Witkin is rarely that literal—but its emotional charge is unmistakable.

After finishing *Her Dream,* Witkin painted a triptych in which he incorporated several photographs into the composition. These pictures within the picture, color Polaroids taken on the spot, show the painting itself unfolding. Called *See What I Mean? Let's Try That Pose* (plate 25), the triptych is one of Witkin's most captivating depictions of the behind-the-scenes world of artist and model. The nearly instantaneous results of Polaroid photography are a metaphor for the painting's rendition of the present moment. This narrative tells itself as it is occurring. The painter is hurrying to tie his apron, to approach his blank canvas, as the models look at the group pose he has just photographed; now, of course, these photographs, reality once removed, become an essential part of the new pose.

Like the 1985 *Are You Here? (Sue Ades Posing)* (plate 16) and the 1986 *Breaking the Pose (The Art Class)* (plate 18), this painting makes the viewer privy to the

Fig. 23. *St. Joan, First Version,* 1988. Oil on canvas; 20 × 41 in. Private collection, California

professional yet intimate relationship between artist and model, a relationship in which thrusts of hip and twists of torso, the tilt of a jaw and the droop of a shoulder are symbolic of psychological and emotional states of being. In his journal Witkin wrote excitedly of how "dynamic and alive" the painting was, of how "the space wraps around and includes the viewer." The three models, he noted, were "grace, movement, and mind."

Thoroughly secular, *See What I Mean* nevertheless invokes the sacred. Its composition belies the notion that it is just a painting of models in the studio. Like a Renaissance altarpiece, the four figures form a triangle; the two at either side in black and white frame the golden pair at the center. The yellow-and-white folds of the robes and draped clothing of the central figures suggest an angel's wings; indeed, the lower of the two, holding a Polaroid in either hand, is a figure straight out of an Annunciation scene. Metal poles and the tripod holding the camera trisect the painting vertically just within the actual edges of the canvases, emphasizing the noumenal quality of light, the momentousness of the square black "messages" being conveyed by the angel to the virgin on her throne—an unlikely candidate for sainthood as she leans back, her kimono open, smoking a cigarette.

In addition to the ironic double meanings established by the composition, the painting brings together in an easy and harmonious way the formal devices of the sixteenth and twentieth centuries. The fluid, graceful delineation and deli-

cate modeling of the figures and the drapery are offset by dramatic geometric shapes: the panels of the studio walls, the forceful volumes of the model's platform, the boxy camera, the blank canvas, and, of course, the photographs. The uncompromisingly black void of the Malevich-like square held by the model on the chair covers her breast and draws our gaze toward the mid-point of the painting. On September 8, 1988, Witkin wrote in his journal, "I finally connected with the three models painting!" and added notes for its completion: "working wet into wet, add details, splatters to wall, blue paint (tape) on her yellow robe; real polaroid; in drawings section, add green and pink to floor."

Witkin's focus on the relationship between male artist and female model during the late eighties was related both to the tumultuous nature of his personal life and to his need for relief from his renewed involvement with Hitler's Germany. Chris and Gwen had left Holland to live in Syracuse and attend the university there (where they could receive remitted tuition benefits as a faculty member's dependents). Not long after they settled in, they found their father's marriage on the skids—he had fallen deeply and passionately in love with a young women who was studying in the museology program at Syracuse University. It was a time of inner torment for Witkin, who had hoped to provide a stable domestic environment for his children but now found himself unable to maintain a marriage that had become, for him at least, an emotional wasteland. In the fall of 1987, he acknowledged all of

this to Judi, and they agreed to a separation and eventual divorce.

During that period of endings and new beginnings, Witkin was finishing *A Jesus for Our Time* and the Holocaust-related painting *Terminal* (plate 23), a ten-foot high, six-foot-wide diptych that depicts a young man, wearing a yellow star, who sits in a boxcar amid suitcases and crates, sacks, and straw. He looks out at us through the door, completely without expression, as if any possibility of emotion had long been beaten out of him. He sits, hands folded loosely in his lap, as though he has been forever thus. We regard him regarding us, and as we do we imagine the barked orders, the selection process that will inevitably end in death. The painting's lower panel depicts the wheels and other mechanical parts of a railway train; a step juts out toward our feet. The composition of the piece sets us squarely in complicity with the Nazi regime: extending in from the side of the canvas, a pair of hands gripping a metal bar are about to close the door. Thrust sharply into the foreground, they could be our own.

There is very little color in this painting. Everything is black, white, and the tones of flesh and wood, leather and straw. The white square behind the man's head resembles a window but frustrates any hope of one: it is thick and opaque, a torn sheet of paper against a swath of black that refuses to remain on one plane, that drips against the white wall. On the floor is a small coin, a cross-cultural reference to the payment Charon exacts for ferrying the souls of the dead across the river Styx.

In a presentation made before the Council for the World's Religions, Betty Rogers Rubenstein said of this painting, "The entrapment of the soul registers here. The body breathes but the very air is dead. Yes, there is baggage and preparation for a journey . . . but the destination is dissolution into nothingness. The hiking boots will take him only to the gas chamber. . . . The silence in this work is as deafening as the scream in *Death as an Usher*."[4]

Pondering his first three paintings in the Holocaust series, Witkin says, "*The Devil as a Tailor* is symbolic. *Death as an Usher* represents fear. *Terminal* is about endurance. They all anticipate a hands-on-body experience." That experience informs the 1989–1990 works *Beating Station and After, Berlin, 1933* (plate 26) and the unfinished *Event and Witness* (fig. 24), which were preceded by the 1989 single-panel *Liberation, 1945* (plate 24). Unlike the other paintings in the Holocaust series, *Liberation* is nearly bare of human presence; its power lies in its confrontation with the mute facticity of objects—here, a stone wall. Amid the layers of broken rock and crumbling mortar, the torn poster, the detritus scattered on the cement floor, we nearly miss the figure in an inmate's striped uniform. He is kneeling as if in prayer, his back toward us, obscured by the long column of shadow. The palette is restricted to moss greens, grays, silvery whites. Just left of center, bathed in light, is the round protrusion of a pipe. It looks like a gun barrel.

The wall, which figures prominently in the Holocaust paintings and drawings

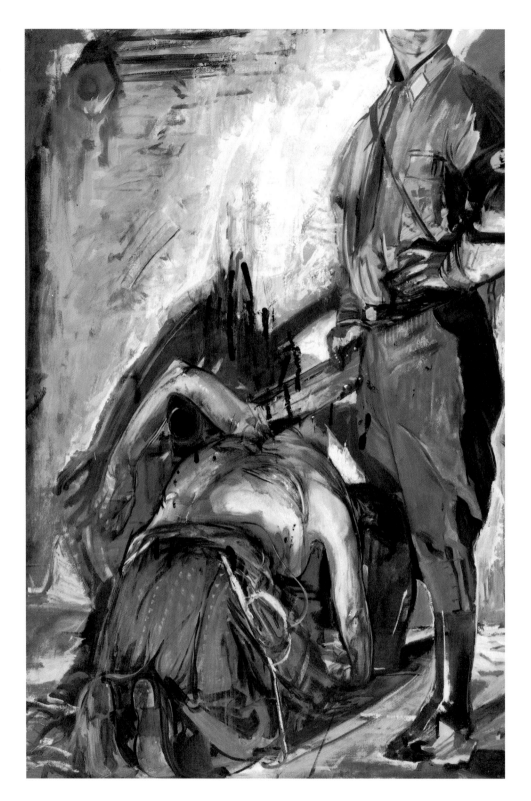

Fig. 24. *Event and Witness*, 1989. Study for left panel of unfinished painting

64

of 1989–1990, including a number of watercolors and oil sketches, was an inspired discovery made while seeking the right backdrop for *Event and Witness.* Witkin found the wall in the labyrinthine basement of the Delavan Center, three floors beneath his studio. It became a crucial element, providing him with the authenticity he requires of his backdrops. "The thing I've always loved in painting is to represent places as the mind, as the mental state," he says.

While working on *Event and Witness,* the painter wrote in his journal, "Just now I'm fighting just how *descriptive* I should stay. The *soul,* the realness of the image, its *thereness,* is the thing to work for. This is *why* one paints." A large diptych, the painting portrays a naked woman being savagely beaten by a Nazi soldier on one panel; on the other, a second woman lies in bed, dreaming. The psychological ambiguity of real time and dream time adds to the discomfort generated by the graphic depiction of physical brutality. Are the two events occurring at the same moment? Is what is being shown on the left a recurring nightmare in the mind of the sleeping woman on the right? Was the entire Holocaust just a terrifying dream? Or is the victim of the endless blows projecting herself back into a safe bed, a memory of refuge?

Event and Witness was problematic from the start. Witkin had trouble with the scale, the palette, the facticity of the gore, the portrayal of the woman dreaming. He was working against his artistic elegance more than he ever had before; he wanted, as he put it, "to show some-thing so repulsive that it wouldn't fit the expected." But after working on it for a year, he put it aside. "I couldn't paint the blood," he says in retrospect. "I couldn't replicate an event that couldn't be known to me—I couldn't give it the reality it needed. Metaphor and simplicity go a long way. I need the poetic option."

It was painful to abandon a work that seemed an important part of the Holocaust series, but he was already involved with *Beating Station and After, Berlin, 1933* (plate 26), which was evolving with a freshness and vigor the belabored diptych lacked.

"There's a relationship with a painting's progress that's like any relationship," he noted in his journal. "It's a dance of interest, doubt, closeness, and openness. It's a burden, and we are first in control, and then we lose it. Some days we click, others we don't. At the end we can become precious and safe, or risk change again. If we trust, we risk." In another entry he wrote, "I know I'm taking on very dramatic painting (images) yet I also know myself—I proceed on instinct and grit. I wish to find the *truth* of the form and how it is to be painted. The authentic takes time to find. . . . Struggle is the dialogue between the artist and the unknowable. Now I question my motive. Luck, early luck, has run out. It's harder to find it, and yet I sense the momentum to do it best now. Every painting I've ever made demands to know itself through a hard birth. I must be more honest, more intimate, more simple in means, less stagey."

And this often meant heightening the narrative intensity by veering toward

sheer ugliness of color or form, or taking an intentional plunge into the realm of bad taste, as in the thickly smeared rivulets of blood on the figures and across the very picture plane in *Event and Witness* and *Beating Station and After.* It called for an approach that radically opposed his finely tuned aesthetic sensibility, his years of classical training, and his virtuoso abilities, in order to convey the grim mix of terror, bleakness, and brutality that surrounded the Jews of Europe during the Holocaust.

"How do you make mud talk?" Witkin ponders. "In the concentration camps, nothing grows. It's all mud and feces. There's the black and white of the SS uniforms, the barren, dark Polish winters. The difficulty of making ugliness is accepting that textures and colors will be ugly. Guston constantly denied nicety, searching for depth of feeling. I can do dissonance and I can do lyrical. But I don't want to do either/or; I want to mix them up. I want the contrast of the feelings. The elegant passage plays up the

horrific one, by virtue of the element of surprise. Eakins did it too, putting crude and delicate passages in the same painting, and Balthus in his drawings of *Wuthering Heights,* mixing heavy and light strokes; and Edwin Dickinson in *The Cello Player,* with his gray, muddy colors kicking up the blues and oranges."

From a table in his studio, he picks up a small reproduction of Hans Memling's *Chalice of St. John the Evangelist,* ca. 1480. "Look at the quietude, the religious empathy he conveys through his excruciatingly sensitive brushwork. Every stroke is put on as if with a butterfly's wing; your heart feels it. The terre verde scumbled on the back wall breaks it away from the warmth of the chalice. To paint simultaneously as sensitively as this and as crudely as Guston—that's what I'm after."

Nowhere is Witkin's engagement with the gestural mark more apparent than in the late Holocaust paintings: paint sails with seeming abandon over the uncompromising density and grid-like pattern

of the stone wall; shapes dissolve like collapsing bodies. Witkin pushes his work to the edge in these paintings; while flying in the face of his own facility, he reaches an unprecedented unity of form and feeling.

Beating Station and After is an eleven-foot-long sequence of events reflecting a scenario that was enacted with regularity throughout the Holocaust years, and that continues to occur today under totalitarian regimes everywhere from Africa and the Middle East to China and South America: in a dank, dimly lit basement room, prisoners are struck again and again, often to death. In this triptych, the first and longest panel (where the action is) is divided into three sections. Two tattered proclamation posters plastered on the wall, each headlined "Juden" in heavy block letters, locate this scene in Nazi Germany. Strident against the griminess of the floodlit gray stone wall, the pale flesh tones, and the muddy colors of the SS uniforms is the red of splattered blood, a red echoed in the long, horizontal pipes that extend across the wall like stretched-out arteries.

The first section depicts a woman being beaten by an SS officer. The man's dark, faceless figure is distinguished from the stone wall only by the harsh light that also delineates the head, back, and outstretched leg of his prisoner. A second SS man with a wooden beam kneels in the center section of this panel. He, too, is faceless against the brightly lit wall, at the center of which stares a segment of pipe like the barrel of a gun. He is looking at his watch, timing the beat-ing—waiting his turn, perhaps. In any case, this figure also suggests the Nazis' dispassionate recording, in the interests of what they called science, of their victims' physiological responses to pain and mutilation. In the third section of the first panel is a temporal-spatial delay: the crumpled, bloodied figure of the just-beaten woman has been left in a heap in a corner, her left elbow propped over another section of pipe sticking out from the wall. A second woman has entered and stands bowed in anguish at what she sees. Emerging from a dark doorway behind her is yet another horror-stricken figure.

The middle panel is a closeup double take of the second woman. She is bent nearly double in empathetic pain; the amorphous, blood-splattered white figure behind her looks back in terror at a raised weapon wielded by an unseen tormentor. This white shape is transmogrified into the acute angle of bright light that illumines a segment of wall, painted an underwater blue-green, in the third panel, which is something of a companion piece to *Liberation, 1945*. Here, however, instead of a kneeling victim about to be freed, the light against the stone wall illumines nothing but a pile of human bones.

Viewed up close, this triptych is pure abstract expressionist Witkin. Loose and spontaneous, yet articulate, the pigment-laden brush and palette knife have attacked the canvas in an explosion of violent gestures, crosshatches and parallel marks, smears and drips that are the formal equivalent of the content's ferocity.

"No one can now retell Auschwitz after Auschwitz," Elie Wiesel wrote in *From the Kingdom of Memory*. "The truth of Auschwitz remains hidden in its ashes. Only those who lived it in their flesh and in their minds can possibly transform their experience into knowledge." Nevertheless, the author continues, one must "shatter the wall encasing the darkest truth, and give it a name . . . to force man to look."

For Witkin, one of the imperatives of art is to plumb the depths of human experience, to reveal the unknown through the known. As Max Beckmann put it, "If we wish to grasp the invisible, we penetrate as deeply as possible into the visible." In the case of the Holocaust, the visible can only be expressed, Wiesel said, by a "language of night."

Over and over again, Witkin has drilled himself in the dark strophes of that language. "I don't want to be illustrative, but to be illuminating," he says. "I can't, after all, reconstruct the facts; the use of metaphor is more chilling. When I'm asked why I'm doing these paintings, I have to admit that I don't really know. It's a matter of faith. More and more, I'm doing pictures no one is going to buy. All I know is, I have a need to open heavy, dark doors; this is the heaviest, and the darkest. I've put my heart through extremes with this work. I've rubbed my life into it; merged with it."

In the summer of 1990, Witkin traveled to Poland and, carrying his sketchbooks and art supplies, went to Auschwitz. "I saw the rooms of thousands of pounds of human hair, of chil-dren's toothbrushes," he says. "I saw the wall against which 20,000 people were shot. I saw the calcium pits of bones, the pond of ashes from three million people, the methane tanks that converted the prisoners' feces into fuel for the crematoria. I went into one of the women's barracks and saw the three-tiered stalls, like empty kennels for animals, where the women had slept. The rain was coming down in torrents. I ran back to the bus, soaked through, and the next day I went back there, to Barrack 15, and started working on a drawing. I felt the deep shadows, the stillness, the cold; and then while I was working, while I was sitting there in the middle of this emptiness, I began telling those [imagined] women about myself, my family."

Witkin returned the following day and drew the huge public latrine in the men's barracks. "There were sixty-two holes," he says. "They had ten seconds to use them." As he drew, he heard visitors talking, "expressing horror in so many different languages." On the third day, he drew Crematorium 1. "Many people came up to talk," he recalls. "There was a Japanese film crew, and a British woman who said, 'You can realize so much just being here.' And there was a young German girl staring at the oven where thirty thousand people had been exterminated; she was laughing nervously."

After fifty years of inner questioning about being half-Jewish, half-Catholic, Witkin experienced "all that labeling falling away. There, in that place that was all about labels, I felt what it was to be just a human being. I could either feel shame for what human beings had done

to other human beings, or admiration for the strength of those who somehow got through this. What most stays with me from that trip is a sense of the vacuity of Auschwitz. Even the ghosts would rush away from there. And yet, now crowds visit, to learn how to be better human beings, and to pay homage at the biggest cemetery in the world."

The painter's 1990 trip to Europe was very different from his earlier one. "When I was in my twenties, I was a pilgrim to Europe to see the art and the great buildings," he says. "This time I went back to see what the work had to see. As a student, I was empty. Now I'm filled up with what I'm painting."

Upon his return to the United States, he was eager to show the three drawings he had made at Auschwitz. Stark and haunting, they were among the most powerful works of his career. He had rendered with utmost simplicity the bleak confines of Barrack 15, the length of concrete latrine that ran for as far as the eye could see, the tracks on the floor used for carting bodies into and their remains out of the crematoria. With a telling economy of gesture, he evoked an atmosphere of utter silence, of final emptiness.

He had the drawings framed quickly, so that he could ship them out to the Hooks-Epstein Galleries in Houston, Texas, where they would be included in a solo show opening that fall. Because of the time constraints, he did not get them photographed. A few weeks later, we met at Syracuse University's Joe and Emily Lowe Art Gallery, in the new Shaffer Art Building, where the faculty art show had just been installed. Witkin's face was ashen. "What happened?" I asked. "The drawings have been stolen," he said in barely audible tones.

The gallery owners, Geri and Charles Hooks, said they thought anti-Semitism might have prompted the act—an anti-Israeli demonstration and march had taken place in the neighborhood just a few days before the theft. The crime has gone unsolved.

Grief-stricken at the loss, Witkin threw himself back into a triptych he had begun before his trip to Poland. Unlike his other polyptychs, this one does not show scenes with an obvious narrative connection: the contemporary drug-dazed couple in a flophouse would seem to have little to do with the surrealist montage of scenes from the Nazi death camps or the headlong trajectory depicting the mental turmoil of Vincent Van Gogh. Called *Three Men in a Ruin* (fig. 26), the painting depicts, Witkin says, "three victims affected by specific life moments."

Although the events described are unrelated from one seventy-one by eighty-eight-inch panel to the next, the composition, palette, and brushwork are carried through from the decrepit interior of the first to the catapulting, broken planes of the third. The pose of the crack-addled woman on the floor in the first panel (plate 27) is echoed by that of the concentration camp survivor in the second and of the storm-slammed figure of Van Gogh in the third (plate 28). Angles and shapes are repeated, too: the diagonal shadows across the door in the crack house are disembodied striped shirts and hats flying across the left-hand segment

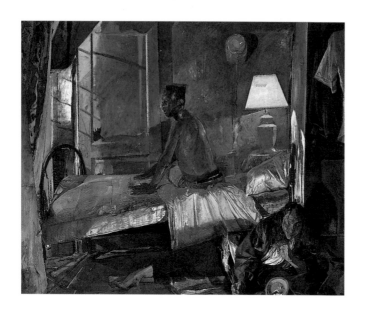
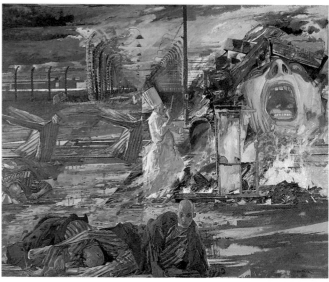

of the middle panel, and in the third are airborne picture frames, stretchers, and an easel. The upward-tilted horizon line of the bed occurs again, repeatedly, in the puddles, the train tracks, the distant grassy strip, and the cross-like shape of fallen beams in the second panel, and in the light-streaked floor and shadows, the hurtling objects. Even the head of the African-American man sitting on the bed is echoed in reverse by the chef's hat in the second, and again in the curved white form near the center of the third. Whereas the first and third panels are like bookends—claustrophobic interiors that are reasonably simple to "read," each thrusting up against the picture plane—the middle one, alternating between deep and shallow space, is a nightmarish montage of shifting time and place. This triptych, with its soft, chalky, smoky tones and visionary imagery, brings the work of Edwin Dickinson to mind. Greys and blues meet muted greens; the artist's touch is light, flowing,

easy, seemingly spontaneous. The painting has an allover seamlessness of expression that belies the shifts in time and place.

In the first scene, the seated man looks out to the left; his bed seems about to take off like a magic carpet through the open doorway, where we glimpse sky and a bit of cityscape. Contrapuntally, his reclining partner in the foreground heads off toward the dark right corner. The daylight traces the door with a soft green glow; the lamp casts a thinner light over the pillow, the sheets, the bare back of the man, the upper body of the woman. Her face is lit by yet another source of light: the yellow flame of the cone of crack cocaine she holds out to the viewer. A bed sheet flows onto the floor, is interrupted visually by the woman's dark robe, then becomes the newspaper onto which she has been cutting cocaine; the paper cone is given the same value.

"The middle panel wouldn't really say what I want it to without the other two,"

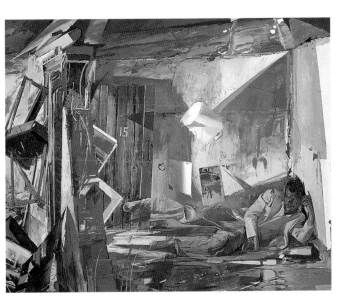

Fig. 26. *Three Men in a Ruin*, 1990. Oil on canvas; triptych, each panel 71 × 88 in. Courtesy of the artist

Witkin says. "History painting forces you to play the present and past at the same time. The woman in the first one could be having a stoned vision of herself in the middle picture; she could be a survivor. In any case, they're ruined, all three: the drug addict, the victim of a death camp, the artist. All are marginal, outsiders."

The endless progression of electrified barbed-wire fencing and rows of tall, curving floodlamps section off the far left corner of the middle canvas, a corner where we can just make out the rows of concentration camp barracks. Inset at the center is the figure of a cook, holding an oven door open, flames leaping around his white-garbed body, which is in the process of disintegrating and vanishing from the knees down. Where his knees would be, we can just make out a figure burning in the furnace. "The cook is Mengele at the moment of making selections; he's being swallowed up by his own creation," Witkin says.

Nearly filling the right-hand section of the canvas is a woman's screaming face, her lipsticked-mouth gaping in a larger version of Mengele's oven. She breaks into a space that is illogical and nonhierarchical, despite the rushing depth perspective suggested by the rows of the floodlamps. Forming a strange, angular sort of headgear is a tumbling structure of wooden beams, a reference to a heroic group of Jewish prisoners who collected enough explosives to blow up the biggest crematorium at Auschwitz-Birkenau.

This inset of cook, oven, disintegrating structure, and screaming face is a tearing of the picture plane, literally an eruption of the ground. "The Holocaust was so anti-life that the entire earth erupted," Witkin says. "The ashes and bones were pushed down into the ground, to hide the evidence. The Germans used their victims' excrement for methane gas as a source of power. They kept ducks so that the quacking would cover up people's screams." The

71

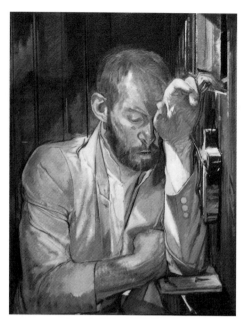

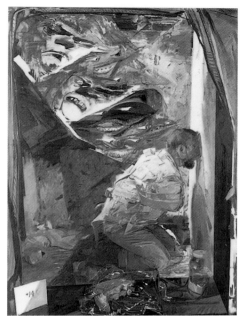

Fig. 27. *Van Gogh in a Confessional,* 1987. Oil on canvas; 30 × 20 in. Collection of Georgia and Nathan Kramer, New York City

Fig. 28. (right) *In a Mind, My Vincent,* 1988. Oil on canvas; 60 × 48 in. Courtesy of the artist

disembodied striped uniforms, their sleeves drawn back with the force of their swift movement from left to right, are indeed like flapping ducks hurrying over the corpses, across the muddy, puddle-streaked earth.

How does one paint wind? What is the color of air? In the third panel only the barest amount of pigment is used, often applied with the palette knife directly to the canvas. Even the solid forms of easel and brush, stretchers and canvases, even the figure itself, seem as insubstantial as the light that enters through an unseen hole in the roof. With its paintings within a painting, its planes within a plane, this third panel is emblematic of

art's uneasy relationship with life. The artist in a ruin (mental, spiritual, physical) is victimized by his own efforts to escape. Van Gogh is blown away, thrown up against the wall by the Mistral, a symbolic force that clears the web of illusions from the artist's eye. Hurtling from hallucination to objective reality, and from the dizzying heights of his artistic vision back to the mean, wooden facts of his meager existence, Van Gogh is the quintessential artistic figure, and for Witkin, he symbolizes both the heroic gesture—despite his mental illness, he returned again and again to the canvas—and the impossibility of escape (figs. 27,28,29).

Fig. 29. *Vincent*, 1988.
Charcoal on paper;
84 × 48 in. Collection
of Erik von Müller,
San Francisco,
California

V ❧ CONCLUSION

To WANT to do abstract painting today—can you really escape what's around you?" Witkin muses. "And yet, if you're doing realist work, what does it do to you? Just going out for groceries, you step over a homeless person on the street. How do you continue to function? And how can you paint a twentieth-century person if you don't realize what people are doing to each other? The historical context can't be ignored. How do you live in a world where Auschwitz happens? And how do you make art of it?

"I've always been like Fred Astaire with a paintbrush. When to show my skill? How not to show off? Using a real situation, I'm forced to enter that situation, that person's space. If I were to paint as an abstract expressionist, the work would be merely decorative."

Like many an artist who has worked against and in spite of the prevailing trends of his or her day, Witkin is given to brooding about his place in the broader scheme of things. "I wish to be remembered as a religious artist who truly attempted to portray the most inti-mate range of human feelings and the meetings of the human with life's demons and deities," he wrote in his journal of 1988. "I wish to enhance the sacredness of life and always present our wonder and our dilemma as catalysts for the observer's feelings. I wish to make images that will console the viewer. Art and the holy are twins. Rembrandt, Kollwitz pray with muddy and bloody hands. Life is hard, and the struggle must, in time, grace the work."

In an entry on January 25, 1989, he wrote, "Just had a very pleasant and most memorable meeting with Jack Levine at his home on Morton Street. Thirty-five years ago [when they first met], I was 15 or 16, and he was 40. Now it was man to man. He and I are very different in belief, approach, and optimism. He wants to throw away, get out of, entrapments (art and life). I embrace challenges more readily (greedily). Yet the gods have been good to me since 15; and he and I both believe we have left something to this world. He and I are outsiders—he is bitter about this (as I am). The art world is a rotten place, yet we've

74

needed it, to place our work and to become known."

Although the much-heralded return to the figure, to the recognizable object, that occurred during the early eighties would seem to have been a hopeful sign for artists like Levine and Witkin, it soon became clear that the neo-expressionist cornering of the art market was more a fashion statement than an authentic path. The "clumsy and primitive" look of much of this work was, Witkin wrote, "a reaction (as in primal scream therapy) to the frustrating limitations of abstract painting and minimalism." Many of these artists' "forms are weak and more mannered than in earlier expressionist styles; the space seems more a void than a dramatic place."

In a studio conversation he said, "We know too much about how an expressionist painting looks; therefore it is too laden with tradition. The element of surprise is now gone, and we get only extremes, or caricatures of others' real torments. The word 'star' is used as an adjective for artists now, in a parallel with Hollywood. Why do these artists, who should be taking chances, want to be such incredible conformists? If we tolerate an art that is empty, are we saying society is also empty? We've lost the contact between life and art. Why are we genuflecting to the status quo of power?"

And in another discussion, he pondered the shallowness and carelessness of much early-eighties neo-expressionist art. "The young postmodern artists are scornful of effort, maturation, ripening, fruition. Do we want fashion, which has its own fascism, or do we want some-thing humane, something that says, 'I was there too'? Doing figurative work is hard. It's like talking to your mother. Lucian Freud is one of the few who can do that. It's heavy and it's the biggest joke at the same time. The human face is the most powerful image. But you can't make it up, you have to build it up. The power of ordinary experience becomes extraordinary. Five painters can look at five apples: one of them can make those apples extraordinary. The point of grace is the level at which an apple, or a body, can be the most profound object around. It's a state of grace, of insight.

"Modern art has been circling the same airport for years, afraid of landing. But where we're landing is the planet earth. Finally, after all of this stuff that Ted Wolff calls the big party of postmodernism, everybody is waking up with hangovers. The hangover is that we do have real heads on our shoulders, and no one has bothered since Cézanne to paint the real head. Art is like the Bikini Islands—it's been bombed by bombast. Something survives; something wants to grow."

Witkin frequently broods over his place in the annals of twentieth-century art. Acknowledging that he will never make what he calls "the *A* List," due not to any failing as a painter but to his unwillingness to jump on anyone's bandwagon, he says, "My sensibility has to make its own journey. You walk through puddles, you walk through dry spots; you walk through cactus, you walk through roses; you just have to keep walking your line. Like Kafka waiting at the door, if you're persistent and

perceptive internally, the door will open. Somehow the soul knows the door opens."

Witkin's sequential paintings and their related single-panel canvases have brought him respect and honor, if not the limelight. He was awarded a Ford Foundation grant in 1976 and again in 1978; in 1980 he was inducted into the National Academy of Design. After solo shows of his work at Kraushaar Galleries in New York City, at the Lake Placid Center for the Arts, and at a number of university galleries, a ten-year survey of Witkin's work, consisting of eighty-six paintings and drawings, was organized in 1983 by Pennsylvania State University's Museum of Art (now the Palmer Museum of Art). The exhibition traveled to the Columbia Museums of Art and Science in South Carolina, the Everson Museum of Art in Syracuse, and the Arkansas Art Center in Little Rock.

In 1985, Witkin switched from Kraushaar Galleries to Sherry French Gallery in New York City. French organized a solo show that traveled to the Schick Art Gallery at Skidmore College in Saratoga Springs, New York; that same year, his show "Fourteen Years of Drawing" opened at the Community College of the Finger Lakes in Canandaigua, New York. During the following two years, a solo exhibition called "Moral Visions, A Retrospective" opened at the Marsh Gallery at the University of Richmond in Virginia and traveled to the Pyramid Art Center in Rochester, New York; the Rockford Art Museum in Rockford, Illinois; and the Triton Museum of Art in Santa Clara, California. Other recent solo venues have included the Delaware Art Museum in Wilmington; the Fitchburg Museum in Fitchburg, Massachusetts; the Atrium Gallery at the University of Connecticut, Storrs; and his galleries, Sherry French in New York, K Kimpton in San Francisco, and Hooks-Epstein in Houston. He has participated in group exhibitions in nearly every museum in the country, including the Hirshhorn, the Jewish Museum, the Yale University Art Gallery, Wadsworth Atheneum, the Chrysler Museum, the Minnesota Museum of Art, and the Carnegie Institute.

The number of public collections to own his work has increased steadily, to include the American Academy of Arts and Letters; Galleria degli Uffizi, Florence, Italy; the Hirshhorn Museum and Sculpture Garden; the Metropolitan Museum of Art; the Cleveland Museum of Art; the Everson Museum of Art; the Memorial Art Gallery at the University of Rochester; the Minnesota Museum of Art; the Palmer Museum of Art at Pennsylvania State University; the Museum of Fine Arts in Houston, Texas; and West Publishing Company of St. Paul, Minnesota.

The critical response to Witkin's work has been positive, in spite of the fact that his paintings are difficult to categorize, integrating as they do the rawness and immediacy of abstract expressionism with the premeditated compositions and rigorous technique of High Renaissance painting, and the serial frames of comic books and larger-than-life dramas of the cinema with the flowing narratives of Asian scrolls.

"Witkin's oeuvre," wrote Sally Eauclaire in *Art in America,* "indicates that if fame is to come to him, it must be on his terms. . . . Eschewing the cool detachment, desaturated color, uniform finish and photographic codification of space typically associated with post-Modernist figuration, Witkin prefers animated brushwork, rich color, tactile paint surface and Abstract Expressionist pictorial vibrancy."[1]

In the same magazine, Gerrit Henry wrote of *Death as an Usher* when it was on view at Kraushaar Galleries, "The painting, in its stylistic realism and raw emotional power, has all the traumatic staying-power of the shower scene from 'Psycho'—it invades the imagination, taking title to it by a horrible act of violence. . . . we are given not simply the dumb frisson that might have been expected, but a human experience of the first magnitude."[2]

John L. Ward, in *American Realist Painting 1945–1980,* noted that Witkin's "achievement is to present the modern world in all of its harsh stridency while suggesting the moral seriousness of the artistic endeavor."[3]

In an *Arts Magazine* piece, Theodore Wolff admired Witkin's "remarkable ability to consolidate every aspect of his talent, and to direct his accrued skills toward the most effective realization of his objectives. . . . The result is a body of work that already is beginning to alter our perceptions of what is possible in pictorial narration, and that promises even more dramatic and psychologically probing accountings of some of mankind's more provocative and disturbing actions and events."[4]

John Arthur, in his book *Spirit of Place,* wrote: "Jerome Witkin is . . . an artist of grand and complex pictorial ambitions and possesses extremely seductive painterly skills, which are coupled with a gift of authoritative draftsmanship. While he can charm with the painterly grace of John Singer Sargent, he often simultaneously disrupts the spell he has cast through the emotional weight of his complex, turbulent themes."[5]

And in *Out of Eden: Essays on Modern Art,* W.S. Di Piero noted, "Anecdote is essential to Witkin's work, but he pushes against its compactness, its tendency toward oversimplification and the formulaic. Because he possesses a moral imagination—that is, he is concerned with evaluative representations of the qualities of human action—he must remain available to tumultuous surprise. And so he pushes against the constraints of anecdote with aggressive operatic color. . . . The immediate force of Witkin's paintings comes from their act of witness. I don't mean to trivialize his art by suggesting it contains homiletic content or is moralistic. (Unlikely in any event, since the serial paintings are all blistered with mysterious, irrational, utterly unprogrammatic elements.) But his work has a weird restorative power, restoring to us facts of consciousness and of feeling that we hazard to ignore."[6]

In an era in which much art is content with reflecting rather than reflecting *upon* the fragmentation and ambiguity of contemporary life, Witkin refuses to

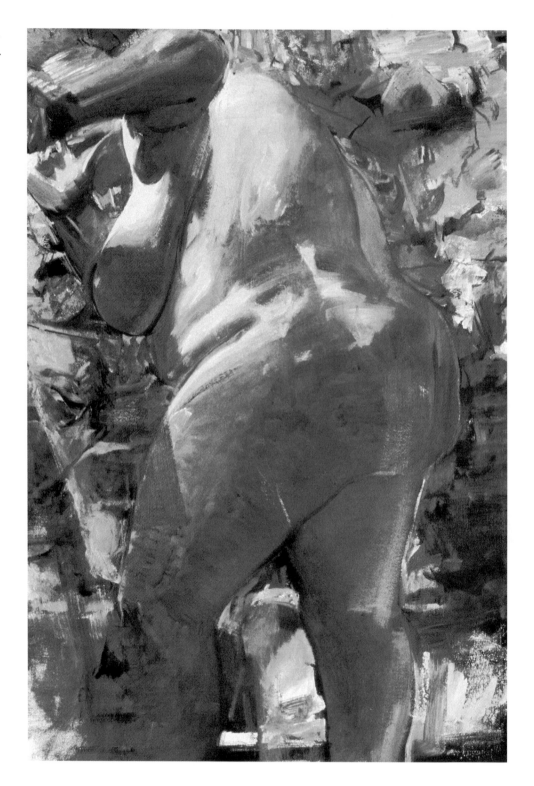

Fig. 30. *Free,* 1990. Oil
on canvas; 24 × 20 in.
Courtesy of the artist

hedge his bets. He is one of the very few contemporary artists for whom art must confront and illumine human behavior, both personal and political. His sense of history gives his work a depth that flies in the face of the banalities of postmodernist thinking. Celebrating the capacity of the human imagination to transcend despair and incoherence, and believing painting to be a vehicle for the direct experience of the nature of truth, he uses every emotional and technical device available to him in order to offer that experience to the viewer. Witkin is creating not for the stratagems and vagaries of the art market but for human beings hungry for a taste of something real. Because his is an art that deals directly with the body, with what is inescapable, it is compelling, challenging, and deeply satisfying.

COLORPLATES

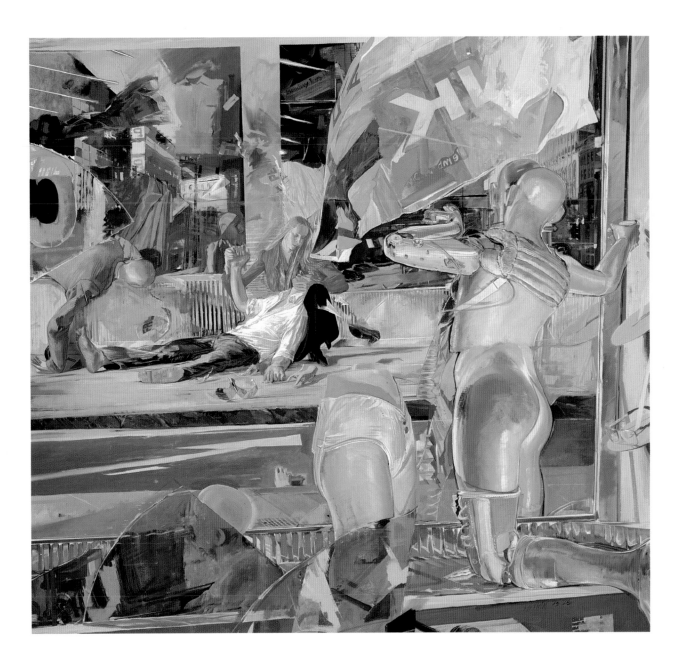

1. *Kill-Joy: To the Passions of Käthe Kollwitz* (detail), 1975–1976. Oil on canvas: 73 × 79 in. Collection of the Palmer Museum of Art, Pennsylvania State University, University Park

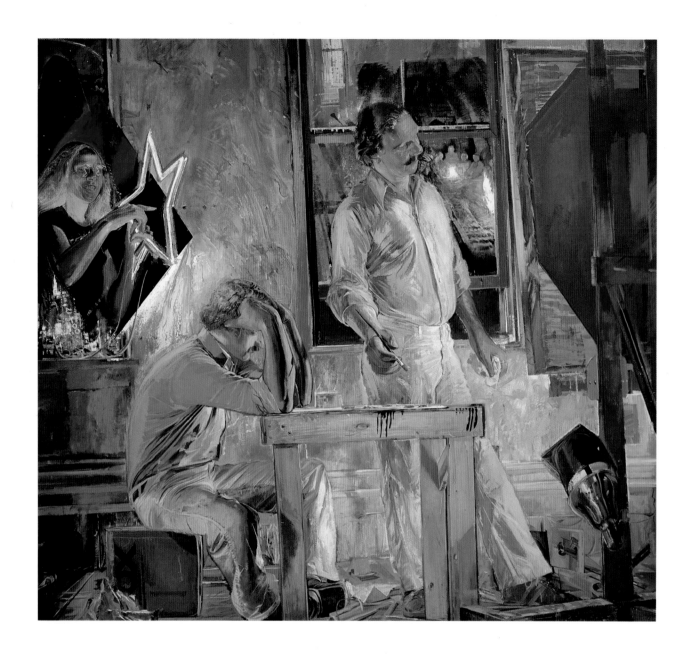

2. *Painter's Crossing:*
To the Passions of
Rembrandt, 1976–1978.
Oil on canvas;
63 × 69 in.
Collection of Howard
Stammer, New York
City

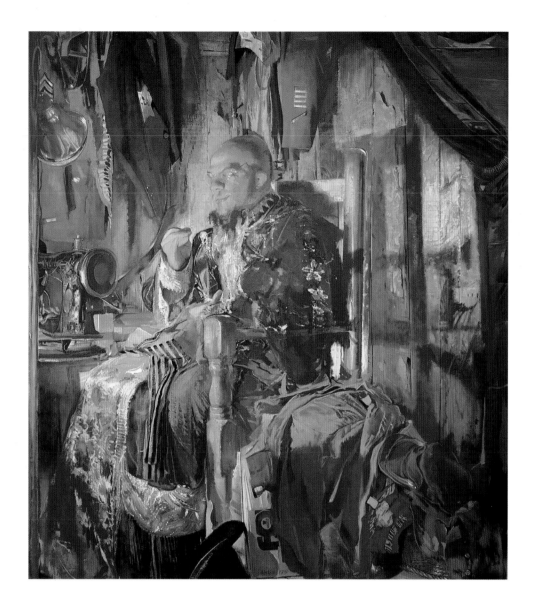

3. *The Devil as a Tailor*, 1978–1979. Oil on canvas; 72 × 65 in. Collection of James and Barbara Palmer, State College, Pennsylvania

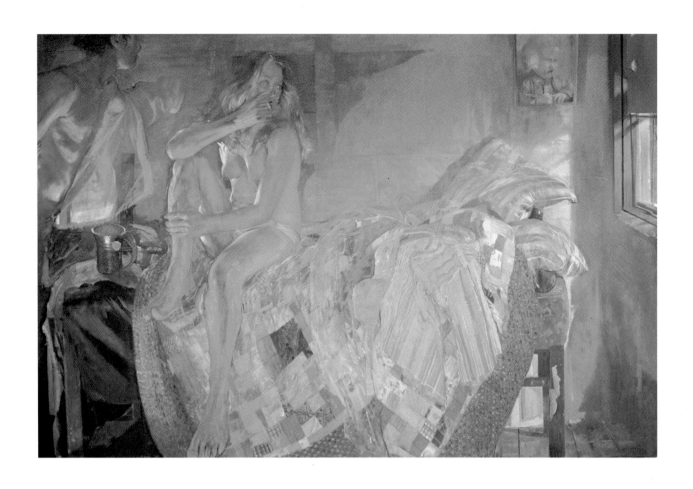

4. *The Screams of Kitty Genovese*, 1978. Oil on canvas; 58 × 84 in. Collection of Joseph Erdelac, Cleveland, Ohio

5. *The Act of Judith,*
1979–1980. Oil on can-
vas; 60 × 48 in. Collec-
tion of the Palmer
Museum of Art,
Pennsylvania State
University, University
Park

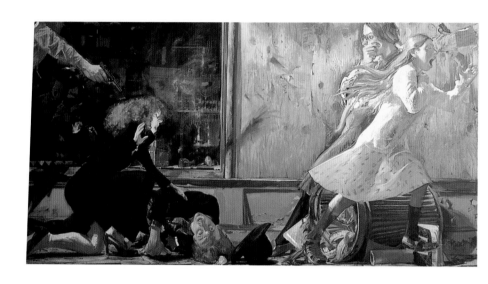

6. *Death as an Usher,*
Berlin, 1933, 1981. Oil
on canvas; triptych.
Panel I, 64 × 122 in.;
Panel II, 92 × 61 in.;
Panel III, 64 × 122 in.
Collection of West
Publishing Company,
St. Paul, Minnesota

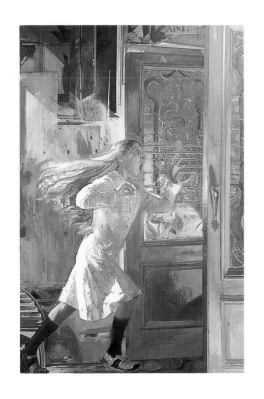

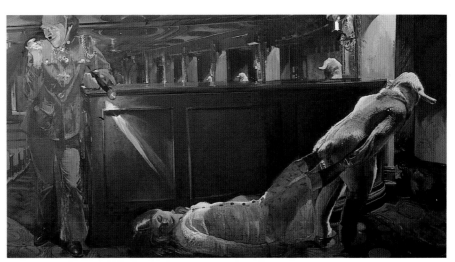

7. *Subway: A Marriage,*
1981–1983. Oil on can-
vas; four panels.
Panel I, 72 × 48 in.;
Panel II, 72 × 54 in.;
Panel III, 72 × 60 in.;
Panel IV, 72 × 66 in.
Courtesy of the artist

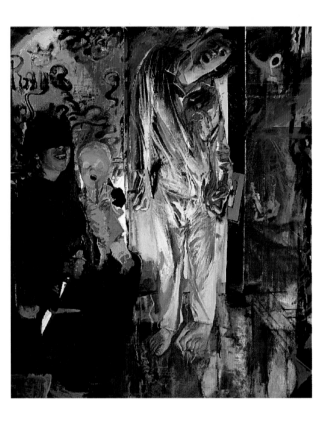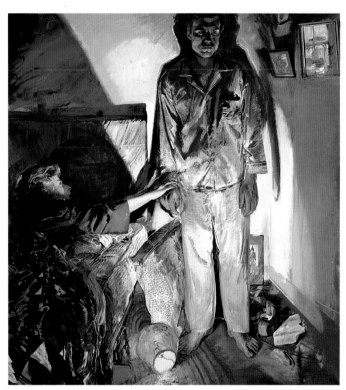

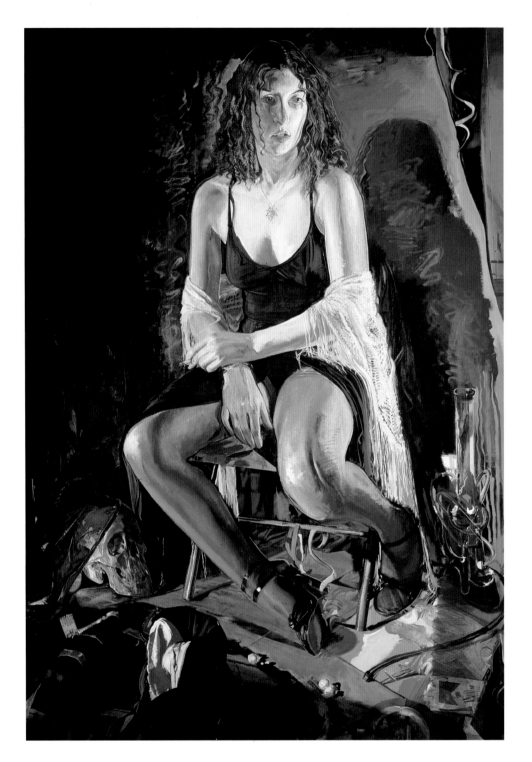

8. *Headstone: Portrait of Claudia Glass,* 1981. Oil on canvas; 72 × 54 in. Collection of the Hirshhorn Museum and Sculpture Garden, Smithsonian Institution, Washington, D.C. Museum purchase, 1982.

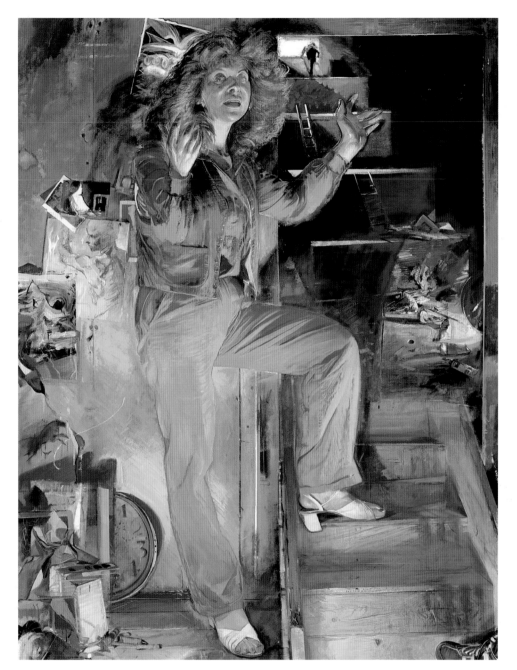

9. *Roberta Braen, the Art Teacher,* 1982–1983, 1985. Oil on canvas; 75 × 56 in. Collection of James and Barbara Palmer, State College, Pennsylvania

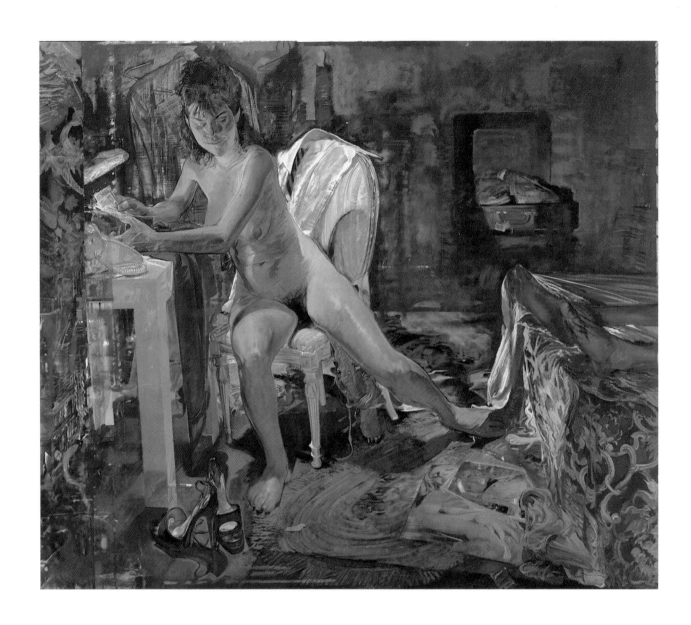

10. *Tit for Tat,*
1983–1984. Oil on can-
vas; 62 × 73 in. Collec-
tion of Georgia and
Nathan Kramer, New
York City

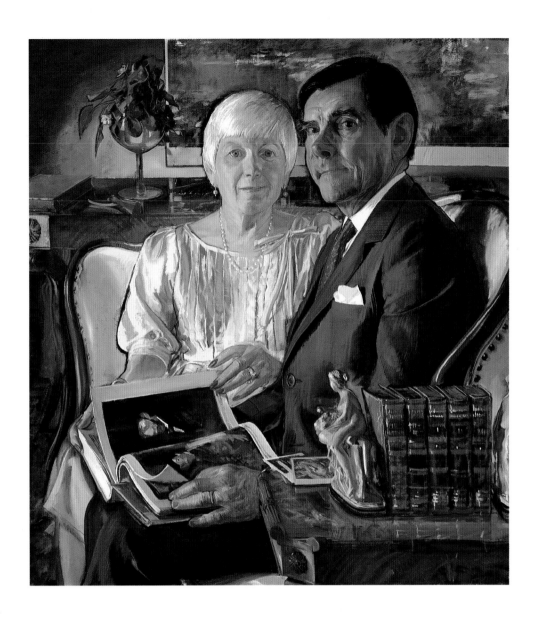

11. *The Palmers,*
1984. Oil on canvas;
44 × 40 in.
Collection of James
and Barbara Palmer,
State College,
Pennsylvania

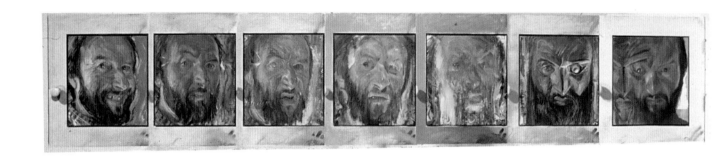

12. *Mind/Mirror: Sud-
denly Remembering
an Insult,* 1984. Oil on
canvas; 21 × 102 in.
Collection of the
Weatherspoon Art
Gallery, University of
North Carolina,
Greensboro

13. *Division Street,*
1984–1985. Oil on can-
vas; triptych.
Panel I, 63 × 75 in.;
Panel II, 63 × 81 in.;
Panel III, 63 × 87 in.
Courtesy of the artist

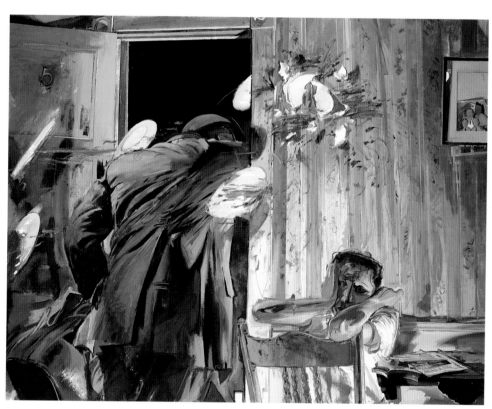

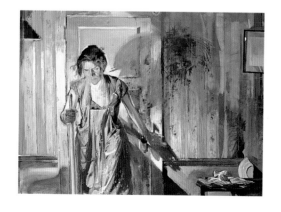

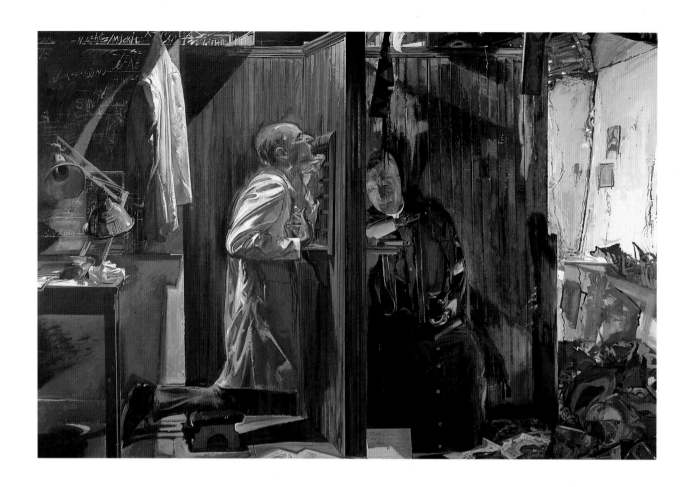

14. *Mortal Sin: In the Confession of J. Robert Oppenheimer*, 1985. Oil on canvas; diptych, 75 × 112 in. Collection of Pamela and Joseph Bonino, San Francisco, California

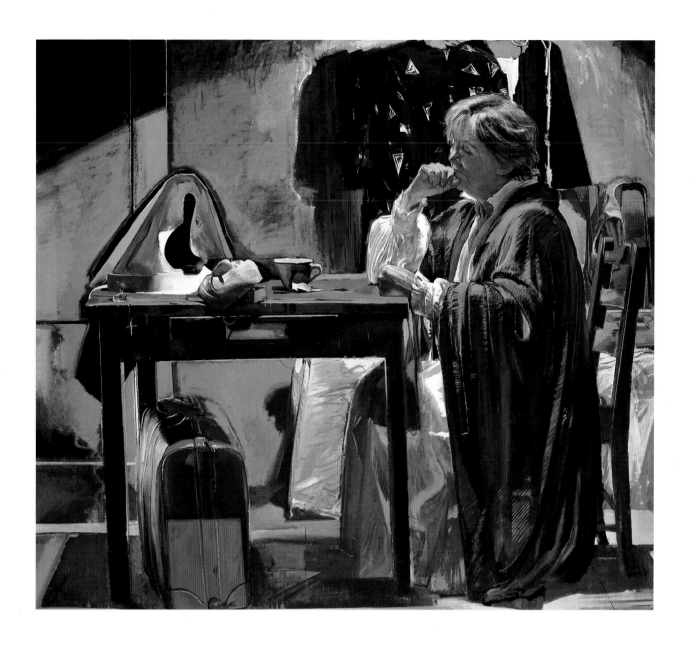

15. *A Nun's Decision,*
1985. Oil on canvas;
63 × 71 in. Collection
of Mary Ann Mott
and Herman Warsh,
Santa Barbara,
California

16. *Are You Here? (Sue Ades Posing)*, 1985. Oil on canvas; 75 × 56 in. Collection of Dr. Francine Sagan, Great Barrington, Massachusetts

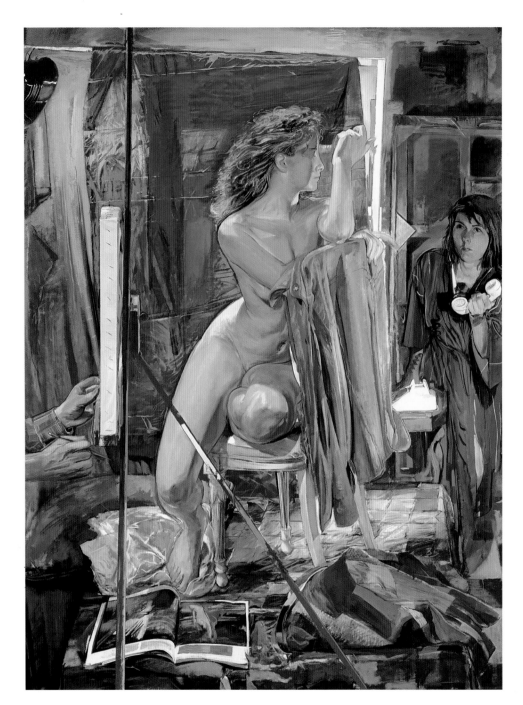

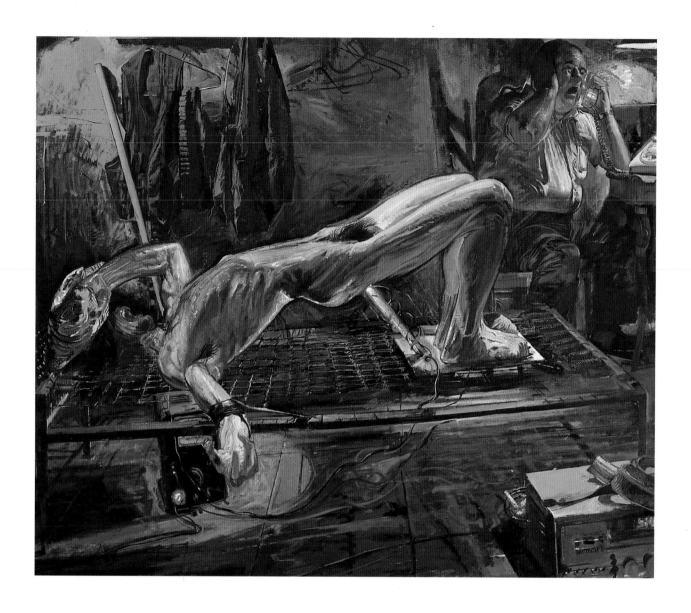

17. *Unseen and Unheard
(In Memory of All Vic-
tims of Torture)*, 1986.
Oil on canvas; 63 × 75 in.
Courtesy of the artist

18. *Breaking the Pose (The Art Class)*, 1986. Oil on canvas; 88 × 71 in. Collection of the Memorial Art Gallery of the University of Rochester, Rochester, New York (Marion Stratton Gould Fund)

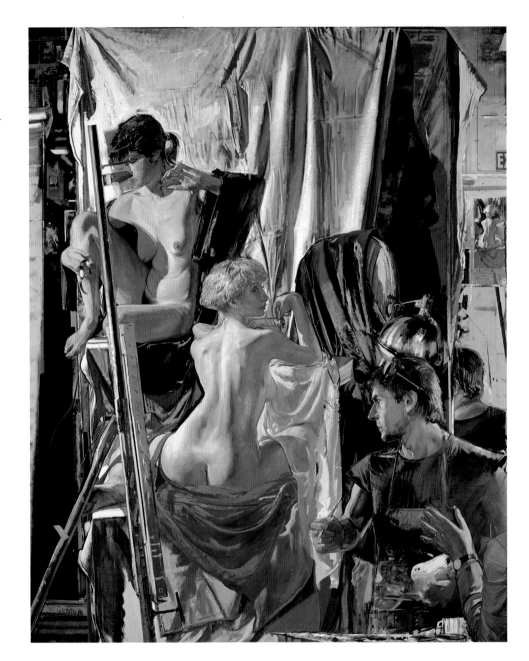

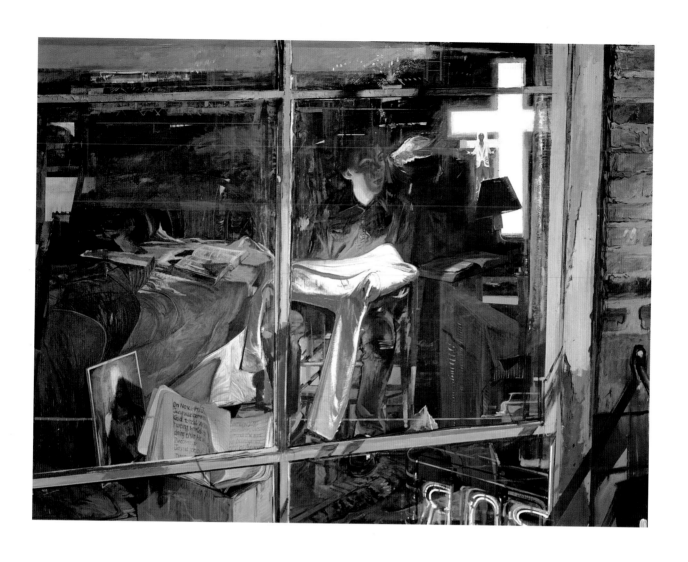

19. *A Jesus for Our Time,* 1986–1987. Oil on canvas; five panels. Panel 1, *The Use of the Suit,* 69 × 91 in.

Panel 11, *Jimmy's Mission to Beirut (Late Afternoon)*, 109 × 71 in.

Panel III, *The Explosion of the Car-Bomb*, 88 × 79 in.; Panel IV, *His Agony and Crack-Up*, 88 × 96 in.

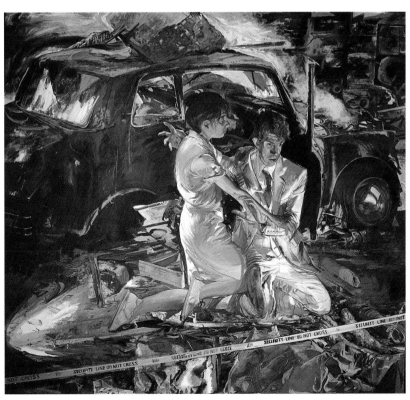

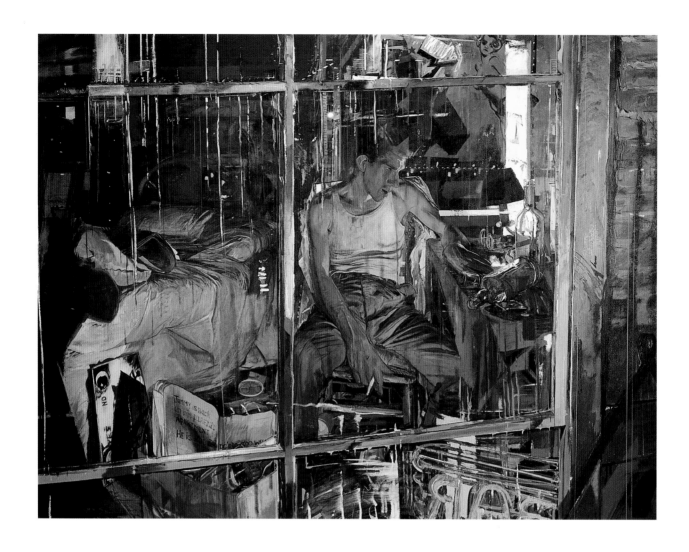

Panel v, *Remembering
the Fire: Jimmy's Back
Home,* 69 × 91 in.
Courtesy of the artist

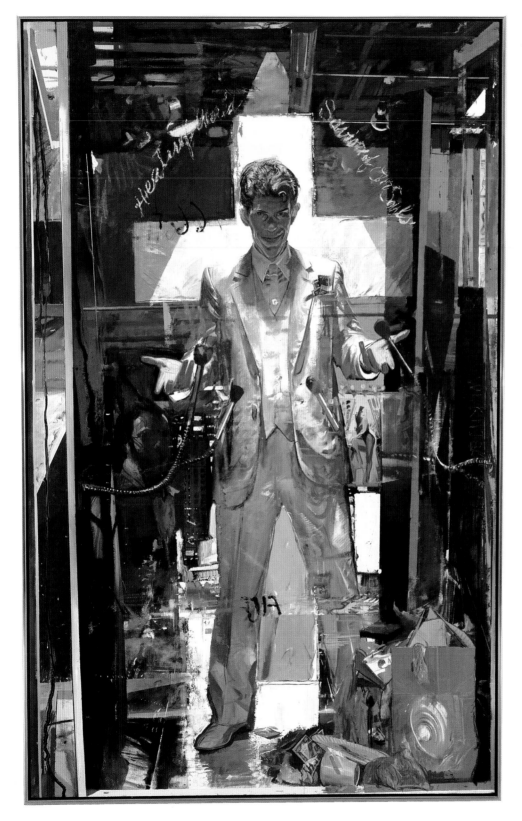

20. *Self-portrait with A Jesus for Our Time,* 1986. Oil on canvas; 72 × 45 in. Collection of Lawrence and Evelyn Aronson, Glencoe, Illinois

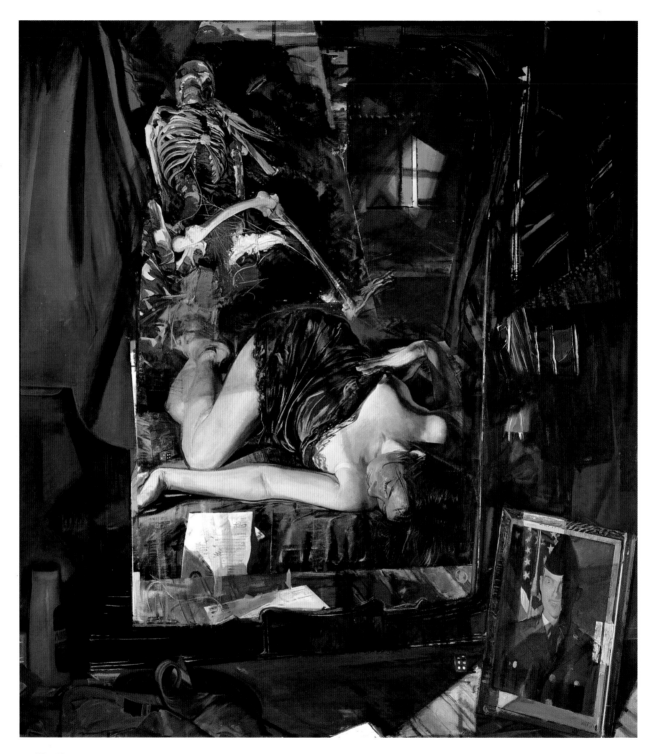

21. *Her Dream,*
1986–1987. Oil on
canvas; 77 × 69 in.
Courtesy of the artist

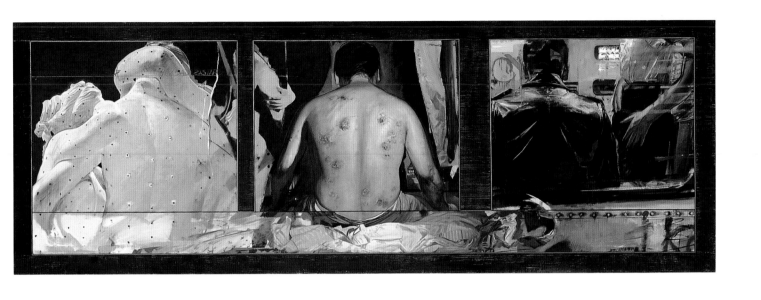

22. *Benny La Terre,*
1987–1988. Oil on can-
vas; 39 3/4 × 108 in.
Courtesy of the artist

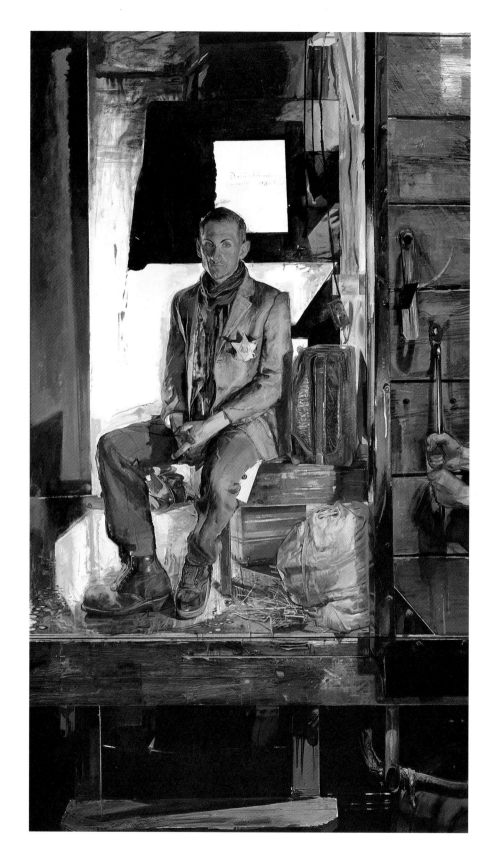

23. *Terminal*, 1987.
Oil on canvas;
123 × 70 1/2 in. Cour-
tesy of the artist

24. *Liberation, 1945*,
1989. Oil on canvas;
36 × 24 in. Collection
of West Publishing
Company, St. Paul,
Minnesota

25. *See What I Mean?*
Let's Try That Pose,
1989. Oil on canvas;
triptych, 84 × 132 in.
Collection of Pamela
and Joseph Bonino,
San Francisco,
California

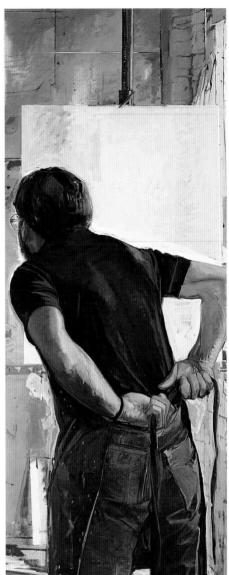

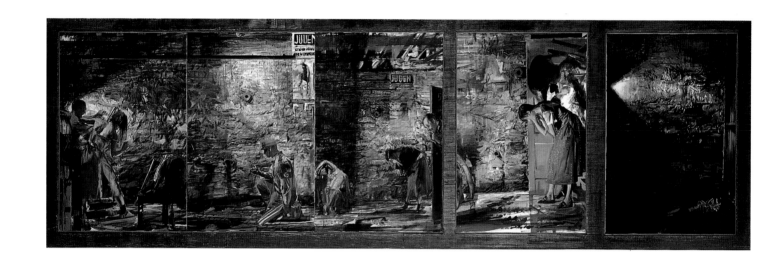

26. *Beating Station
and After, Berlin, 1933*,
1989–1990. Oil on
canvas;
42 1/2 × 132 1/2 in.
Courtesy of the artist

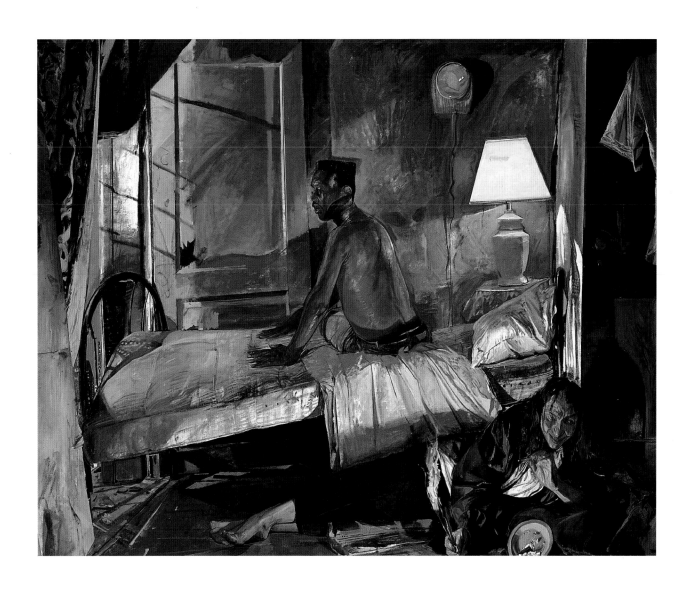

27. *Crack House* (first panel of *Three Men in a Ruin*), 1990. Oil on canvas; 71 × 88 in. Courtesy of the artist

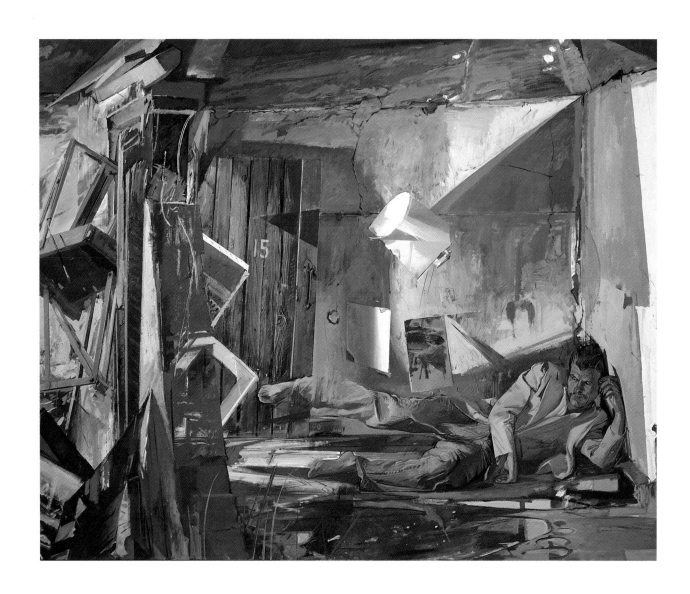

28. *An Artist in a Ruin*
(third panel of *Three
Men in a Ruin*), 1990.
Oil on canvas;
71 × 88 in. Courtesy of
the artist

29. *Figure in a Land-scape,* 1991. Oil on canvas; 108 × 63 in. Collection of West Publishing Company, St. Paul, Minnesota

APPENDIX

CHRONOLOGY

SELECTED EXHIBITIONS

SELECTED PUBLIC COLLECTIONS

NOTES

BIBLIOGRAPHY

APPENDIX: *A Statement on My Technique*

JEROME WITKIN

EVERY YOUNG PAINTER begins with cotton-duck as a support: the surface one paints on. Its cost makes it popular but, like all things personal, one finds that the clearly inexpensive tools, e.g. the canvas, the paint, the brushes, the types of mediums, begin to deny the painting experience.

I found that there is truth to the old adage, "You get what you pay for," especially in the "feel" of the painters' tools.

Linen as a support, with two coats of acrylic-gesso as a primer, has worked well for me. I use only the "artist"-grade oil paint with Titanium White as the paint of choice that is so often the additive to the other colors. My all-purpose medium is to mix six parts gum-turpentine with one part stand-oil and one-and-one-half parts Damar Varnish. This ensures a fast-drying media with the linseed in the tube. This formula dries "matte" and makes for a long-lasting skin of paint.

Because the paint-film is always exposed to different temperatures, it is a good habit to apply as a final retouch-varnish (the only way of bringing all the colors back to their initial look) the following formula: thirteen parts gum-turpentine, six parts Damar, and one part stand-oil. I apply this to a dry ("one-month" dry) surface and apply it only on a clear and dry day.

Lastly, you need to feel that the paint cooperates with you and you with it. We are called painters and one either "thinks through" with the tools or not. Painters use the paint agreeably. Others, because of poor instruction or poor habits, will only feel pain with paint.

After all, I feel the painting experience and the paint experience are really inseparable.

∽ CHRONOLOGY

1939
On September 13, at Bushwick Hospital, Brooklyn, New York, Jerome Paul and Joel-Peter Witkin are born to Mary and Max Witkin. Jerome spends first three days of life in intensive care unit.

1943
Max Witkin leaves his family. Six years elapse before he reappears.

1946
Jerome begins Saturday art classes at St. Dominick's Art School in Bushwick section of Brooklyn.

1950
Witkin family moves to Queens.

1953
Enters High School of Music and Art in New York City.

1954
Wins first prize for his illustration in a *Seventeen* magazine contest.

1955
Summer scholarship to Skowhegan School of Painting and Sculpture, Skowhegan, Maine. Gets to know Ben Shahn and George Grosz.

1957
Graduates from High School of Music and Art. Spends summer at Skowhegan. In fall, enters Cooper Union School of Art in New York City.

1960
Graduates from Cooper Union. Wins Pulitzer Traveling Fellowship to Europe; spends several months in Florence, visits Rome. On twenty-first birthday, visits Giorgio Morandi. While in Europe, learns that his father has died.

1961
Travels to Berlin; studies for three months at Berlin Academy; forms friendship with one of Die Brücke founders, Karl Schmidt-Rottluff. Travels to Venice, Naples, Sicily, North Africa. Returns to United States. Wins Guggenheim Fellowship. First solo show opens at Morris Gallery, New York City. First job, teaching at Maryland Institute's College of Art, Baltimore. Meets first dealer, Antoinette Kraushaar.

1962

Meets Kieny Pompen; they marry in Holland, then return to Baltimore.

1965

Takes two-year position as visiting artist at Manchester College of Art, Manchester, England. Solo show at International Gallery, Baltimore, Maryland.

1966

Son Christian Ryder Witkin born.

1967

Takes one-year position as artist-in-residence at American College of Switzerland, Leysin. Daughter Gwendolyn Eve Witkin born.

1968

Solo shows at several galleries in England, including Grosvenor Gallery in London.

1969

Takes family to Philadelphia. Begins teaching at Moore College of Art; enrolls at University of Pennsylvania's Graduate School of Fine Arts.

1970

Receives M.F.A. degree from University of Pennsylvania. Solo show at The Mill, Bucks County, Pennsylvania.

1971

Marriage dissolves; Kieny takes children to Holland. Begins teaching at Syracuse University School of Art. Solo show at B. K. Smith Gallery, Lake Erie College, Painesville, Ohio

1973

Solo show at Kraushaar Galleries. Wins First Julius Hallgarten Prize, 148th Annual Exhibition, National Academy of Design.

1974

Divorce from Kieny is finalized; marries Judi Fliszar. Produces first of large canvases that prefigure mature work, *Days of the Week.*

1975

Visits children in Amsterdam, beginning pattern in which either he goes to Holland or they come to Syracuse on school vacations. Solo show at College Art Gallery, Drew University, Madison, New Jersey.

1976

Receives Ford Foundation Grant. Finishes *Kill-Joy: To the Passions of Käthe Kollwitz* and beings *Painter's Crossing: To the Passions of Rembrandt.* Solo show at Kraushaar. Two-person show (with fellow Syracuse University art professor Gary Trento) at Everson Museum of Art, Syracuse. Raphael Soyer writes catalogue statement about Witkin.

1977

Begins series of psychological-narrative portraits. Solo show, Fine Arts Center, State University of New York College at Cortland.

1978

Receives second Ford Foundation Grant. Solo show, Museum of Art, Pennsylvania State University (now the Palmer Museum of Art), University Park.

1979

Begins *Death as an Usher: Germany, 1933* and finishes *The Devil as a Tailor.* Immersed in readings about the Holocaust.

1980

Receives Paul Puzinas Award, National Academy of Design.

1981

Fund Purchase Prize, American Academy of Arts and Letters. Begins psychotherapy; starts *Subway: A Marriage.* Solo shows at University Art Galleries, University of New Hampshire, Durham, and Tyler Art Gallery, State University of New York College at Oswego. Finishes *Death as an Usher* on December 3, 1981.

1982

Shows new work at Kraushaar; favorable review by Gerrit Henry in April issue of *Art in America.* Moves into studio at Delavan Center.

1983

Traveling show, "Jerome Witkin, Paintings and Drawings: A Decade of Work," organized by the Museum of Art, Pennsylvania State University (now the Palmer Museum of Art). Other venues are Columbia Museums of Art and Science, Columbia, South Carolina; Everson Museum of Art, Syracuse; Arkansas Arts Center, Little Rock.

1983–1984

Concentrates on portraiture; finishes *Subway: A Marriage;* begins *Division Street.*

1985

Completes *Division Street.* Leaves Kraushaar Galleries for Sherry French Gallery. First solo show at Sherry French travels to Schick Art Gallery at Skidmore College, Saratoga Springs, New York. Solo show, "Fourteen Years of Drawing," opens at Community College of the Finger Lakes, Canandaigua, New York. Begins *Mortal Sin: In the Confession of J. Robert Oppenheimer* and *Unseen and Unheard (In Memory of All Victims of Torture).* Period of doubt and confusion at home and at work. Preliminary sketches for *A Jesus for Our Time.* Christian and Gwendolyn move to Syracuse to attend college.

1987

Included in 162nd Annual Exhibition, National Academy of Design. "Moral Visions: Jerome Witkin" opens at the Marsh Gallery at the University of Richmond and travels to the Pyramid Art Center in Rochester, New York; the Rockford Art Museum in Rockford, Illinois; and the Triton Museum of Art in Santa Clara, California. Finishes *Terminal* and *A Jesus for Our Time.* Solo show at Sherry French Gallery travels to Delaware Art Museum, Wilmington. Separates from Judi.

1988

Finishes *Benny La Terre,* begins *See What I Mean? Let's Try That Pose.*

1989–1990

Continues working on Holocaust theme with *Liberation, 1945, Event and Witness,* and *Beating Station and After: Berlin, 1933.* Travels to Poland, where he draws the barracks, the latrine, and the crematorium at Auschwitz. That fall, drawings are stolen from exhibition at Hooks-Epstein Galleries, Houston, Texas. Finishes *Three Men in a Ruin.* Solo show, "The Holocaust Paintings," K Kimpton Gallery, San Francisco. Divorced from Judi.

1992

Solo show, "Jerome Witkin: Dreams, Portraits, and Murder," Arnot Art Museum, Elmira, New York, and Sherry French Gallery. Solo show, "Jerome Witkin: War and Liberation," Memorial Art Gallery, University of Rochester. Marries Lisa Pennella.

∾ SELECTED EXHIBITIONS

SOLO EXHIBITIONS

1992
"Jerome Witkin: Dreams, Portraits, and Murder," Arnot Art Museum, Elmira, New York, and Sherry French Gallery, New York City. "Jerome Witkin: War and Liberation," Memorial Art Gallery, University of Rochester, Rochester, New York.

1991
Oxford Gallery, Rochester, New York.

1990
"The Holocaust Paintings," K Kimpton Gallery, San Francisco, California. "A Personal Journey," Hooks-Epstein Galleries, Houston, Texas.

1988
Ivory/Kimpton Gallery, San Francisco, California. Atrium Gallery, University of Connecticut, Storrs. Hooks-Epstein Galleries, Houston, Texas.

1987
"Here and Now," Greenville County Museum of Art, Greenville, South Carolina. "Jerome Witkin," Sherry French Gallery, New York City, and Delaware Art Museum,

Wilmington. "Moral Visions: Jerome Witkin" Jerome Witkin Marsh Gallery, University of Richmond, Richmond, Virginia; Pyramid Art Center, Rochester, New York; Rockford Art Museum, Rockford, Illinois; Triton Museum of Art, Santa Clara, California; catalogue.

1986
Jerome Witkin and Joel-Peter Witkin Twin Exhibition, Columbia College Art Gallery, Chicago, Illinois. "Breaking the Pose," Memorial Art Gallery, University of Rochester, Rochester, New York.

1985
Sherry French Gallery, New York City; traveled to Schick Art Gallery, Skidmore College, Saratoga Springs, New York; catalogue. "Fourteen Years of Drawing; 1971–84," Community College of the Finger Lakes, Canandaigua, New York; catalogue.

1984
"Trial Drawings," Syracuse Stage, Syracuse, New York; catalogue.

1983
"Jerome Witkin, Paintings and Drawings: A Decade of Work," Palmer Museum of Art, Pennsylvania State University, University

Park; traveled to Columbia Museums of Art and Science, Columbia, South Carolina; Everson Museum of Art, Syracuse, New York; Arkansas Art Center, Little Rock.

1982
Kraushaar Galleries, New York City.

1981
University Art Galleries, University of New Hampshire, Durham. Tyler Art Gallery, State University of New York College at Oswego.

1979
Kraushaar Gallery, New York City.

1978
Palmer Museum of Art, Pennsylvania State University, University Park. Lake Placid Center for the Arts, Lake Placid, New York.

1977
Fine Arts Center, State University of New York College at Cortland.

1976
Kraushaar Galleries, New York City.

1975
College Art Gallery, Drew University, Madison, New Jersey.

1973
Kraushaar Galleries, New York City.

1971
B. K. Smith Gallery, Lake Erie College, Painesville, Ohio.

GROUP EXHIBITIONS

1992
"Art and the Law," circulated by West Pub-

lishing Company; catalogue. "I, Myself, and Me, Twentieth-Century and Contemporary Self-Portraits," Midtown Payson Galleries, New York City.

1991
"Jerome Witkin and Christian Witkin: Father and Son," Cazenovia College, Cazenovia, New York. "Less is More: Small Work," K Kimpton Gallery, San Francisco, California. "Focus on Art, 1991," National Council of Jewish Women, Livingston, New Jersey. "Against the Grain: Images in American Art, 1960–1990," Southern Alleghenies Museum of Art, Loretto, Pennsylvania. "Scale and Content: Oversized Paintings about Life in the Late Twentieth Century," Appalachian Summer Arts Festival, Appalachian State University, Boone, North Carolina; catalogue.

1990
"Art and the Law," circulated by West Publishing Company; catalogue. "Collectors' Show," Arkansas Art Center, Little Rock. "Empire State Biennial," Everson Museum of Art, Syracuse, New York.

1989
"Portraits: Here's Looking at You," Anchorage Museum of History, Anchorage, Alaska; catalogue; cover illustration. "Made in America," Virginia Beach Center for the Arts, Virginia Beach, Virginia. "Revelation and Devotion: the Spirit of Religion in Contemporary Art," Sherry French Gallery, New York City; traveled to Triton Museum of Art, Santa Clara, California; Art Gallery at Gustavus Adolphus College, St. Peter, Minnesota; Valparaiso University Museum of Art, Valparaiso, Indiana; Arnot Art Museum, Elmira, New York.

1988
"American Art Today: Narrative Painting,"

Florida International University, Miami, Florida. "The Figure in American Art Since Mid-Century," Silvermine Gallery, Stamford, Connecticut. "National Drawing Invitational," Arkansas Art Center, Little Rock. "Life Stories," Henry Art Gallery, University of Washington, Seattle.

1987
"Movietone Muse," One Penn Plaza, New York City. "Studied from Life: Paintings by Contemporary American Artists," Bayly Art Museum at the University of Virginia, Charlottesville. "Night Light/Night Life," Sherry French Gallery, New York City. "Crime and Punishment," Schrieber/Cutler Gallery, New York City. "Morality Tales: History Painting in the 1980s," organized by Independent Curators Incorporated, New York City; originated at Grey Art Gallery, New York University, New York City; then traveled to Berkshire Museum, Pittsfield, Massachusetts; Wadsworth Athenaeum, Hartford, Connecticut; Block Gallery, Northwestern University, Evanston, Illinois; Duke University Gallery of Art, Durham, North Carolina; Sheldon Art Gallery, University of Nebraska, Lincoln; catalogue. "Art and the Law 1987–88," Bar Association of San Francisco, San Francisco, California.

❧ SELECTED PUBLIC COLLECTIONS

Achenbach Foundation for Graphic Arts, San Francisco, California

Alumni Association of the New York State College of Veterinary Medicine, Ithaca

American Academy of Arts and Letters, New York City

Arkansas Art Center, Little Rock

Ball State University, Muncie, Indiana

Butler Institute of American Art, Youngstown, Ohio

Canton Art Institute, Canton, Ohio

Cleveland Museum of Art, Cleveland, Ohio

Columbia Museum of Art and Science, Columbia, South Carolina

Delaware Art Museum, Wilmington

Everson Museum of Art, Syracuse, New York

Fraenkel Gallery, San Francisco, California

Galleria degli Uffizi, Florence, Italy

Hirshhorn Museum and Sculpture Garden, Smithsonian Institution, Washington, D.C.

La Salle College, Philadelphia, Pennsylvania

Memorial Art Gallery, University of Rochester, Rochester, New York

Metropolitan Museum of Art, New York City

Miami-Dade College, Miami, Florida

Minnesota Museum of Art, St. Paul, Minnesota

National Academy of Design, New York City

Palm Springs Desert Museum, Palm Springs, California

Palmer Museum of Art, Pennsylvania State University, University Park

Phillips Exeter Academy, Exeter, New Hampshire

Rhode Island College, Providence

Syracuse University Art Collections, Syracuse, New York

State University of New York College at Cortland

University of Maine at Portland-Gorham

University of New Hampshire, Durham

Museum of Fine Art, University of Utah

Weatherspoon Art Gallery, University of North Carolina, Greensboro

West Publishing Company, St. Paul, Minnesota

❧ NOTES

1. A PAINTER'S CROSSING

1. George Steiner, "Master Class," The *New Yorker,* May 30, 1988, 99.

2. BROOKLYN AND BEYOND

1. Max Kozloff, "American Painting during the Cold War," *Artforum* 11, no. 9 (1973): 43–54.

2. Harold Rosenberg, "The American Action Painters," *ARTnews* 51, no. 5 (1952):37.

3. Seldon Rodman, *Conversations with Artists* (New York: Capricorn, 1961), 91.

4. *Reality: A Journal of Artists' Opinions,* in Jeffrey Wechsler, *Realism and Realities: The Other Side of American Painting, 1940–1960,* Zimmerli Art Gallery, Rutgers University, New Brunswick, N.J., 1981, xx.

5. Charles R. Garoian, *"Killjoy: To the Passions of Käthe Kollwitz,"* The Museologist 51, no. 176 (1987):2.

3. THE HUMAN CONDITION

1. Richard Porter, Introduction, in William Davis and Richard Porter, *Jerome Witkin: A Decade of Work,* Palmer Museum of Art, Pennsylvania State University, 1983.

2. Gerrit Henry, "Jerome Witkin at Kraushaar," *Art in America,* 70, no. 4 (1982):136–137.

3. Jerome Witkin, interview by Virginia Speer, March 29, 1986, printed in the catalogue that ac-companied the traveling show "Moral Visions: Jerome Witkin" of the same year.

4. AVATARS IN DARK CORNERS

1. Richard Rhodes, *The Making of the Atomic Bomb* (New York: Simon and Schuster, 1986), 674.

2. Ibid., 676.

3. Gerrit Henry, "Witkin's Moral Art," a catalogue essay accompanying Witkin's traveling exhibition "Moral Visions," organized jointly by the Marsh Gallery of the University of Richmond, Virginia, and the Pyramid Arts Center of Rochester, New York, in the fall of 1986. After its Richmond and Rochester venues, the show went on to the Rockford Museum of Art, Rockford, Illinois, and the Triton Museum of Art, Santa Clara, California, in 1987.

4. Betty Rogers Rubenstein, "... And Then There Was the Truth: Introducing the Paintings of Jerome Witkin," a lecture given at a conference of the Council for the World's Religions, "The Varieties of Jewish Approaches to Redemption," Sept. 17–22, 1987, Kiamesha Lake, New York.

5. CONCLUSION

1. Sally Eauclaire, "Jerome Witkin at Kraushaar," *Art in America* 67, no. 3 (1979):141.

2. Gerrit Henry, "Jerome Witkin at Kraushaar," *Art in America* 70, no. 4 (1982):137.

3. John L. Ward, *American Realist Painting,*

1945–1980 (Ann Arbor, Mich.: UMI Research Press, 1989), 173.

4. Theodore F. Wolff, "Pictorial Mythology: The New Paintings of Jerome Witkin," *Arts* 60, no. 3 (1985):67.

5. John Arthur, *Spirit of Place: Contemporary*

Landscape Painting and the American Tradition (Boston: Bulfinch Press, Little, Brown, 1989), 66, 70–71.

6. W. S. Di Piero, *Out of Eden: Essays on Modern Art* (Berkeley: Univ. of California Press, 1991), 212, 217.

✌ BIBLIOGRAPHY

Adcock, Craig. *Nocturnes and Nightmares.* Exhibition catalogue. Tallahassee: Florida State University Gallery and Museum, 1987.

Appelhof, Ruth Ann. "Portrait of a Survivor: An Interview with Jerome Witkin." *Syracuse Guide,* no. 29 (Jan. 1978).

Arthur, John. *Spirit of Place: Contemporary Landscape Painting and the American Tradition.* Boston: Bulfinch Press, Little, Brown, 1989.

Ashton, Dore. *The New York School: A Cultural Reckoning.* New York: Penguin, 1972.

Baker, Kenneth. "Jerome Witkin Stars in 'Living on the Edge' Show." *San Francisco Chronicle,* May 12, 1986.

———. "Paintings Not to Miss: Jerome Witkin in Santa Clara." *San Francisco Chronicle,* June 19, 1987.

———. "Elegant Visions of a Nightmare World." *San Francisco Chronicle,* Nov. 23, 1990.

Brenson, Michael. "Art: 1980's History on Canvas in 'Morality Tales.'" *New York Times,* Oct. 16, 1987.

Chayat, Sherry. "Painting the Holocaust, Five Decades Removed." *Jewish Observer,* July 26, 1982.

———. "Witkin Drawn to the Plight of the Plowshares Seven." *Syracuse Herald American Stars Magazine,* Dec. 23, 1983.

———. "Jerome Witkin Paints Life by Immersing Himself in It." *Syracuse Record,* Nov. 4, 1985.

———. "Witkin's Narrative Paintings Starkly Realistic." *Syracuse Herald American Stars Magazine,* Nov. 23, 1986.

———. "Love and Compassion." *Syracuse Herald American Stars Magazine,* Sept. 17, 1989.

Cooper, James, "Psychologically Charged Works Reveal Tension of New York Street Life." *New York City Tribune,* Mar. 15, 1985.

Davis, William and Richard Porter. *Jerome Witkin, Paintings and Drawings: A Decade of Work.* Exhibition catalogue. University Park: Museum of Art, Pennsylvania State University, 1983.

Di Piero, W. S. "Force and Witness: On Jerome Witkin." *Arts Magazine* 62, no. 3 (1987): 76–78.

———. *Out of Eden: Essays on Modern Art,* 210–17. Berkeley: Univ. of California Press, 1991.

Eauclaire, Sally. "Jerome Witkin at Kraushaar," *Art in America* 67, no. 3 (1979): 140–41.

Frank, Peter. "Jerome Witkin at Kraushaar." *ARTnews* 72, no. 6 (1973):98.

Gablik, Suzi. *Has Modernism Failed?.* New York: Thames and Hudson, 1984.

Garoian, Charles R. "Killjoy: To the Passions of Käthe Kollwitz." *The Museologist* 51, no. 176 (1987): 2.

Glueck, Grace. "Imagery from the Jewish Consciousness." *New York Times,* "Gallery View," June 6, 1982.

Hammond, Rita. "Jerome Witkin: Painting on the Edge of Doubt." *Syracuse Post-Standard,* Apr. 16, 1985.

Henry, Gerrit. "Jerome Witkin at Kraushaar." *Art in America* 70, no. 4 (1982): 136–37.

———. "Psychologically Charged." *ARTnews* 84, no. 7 (1985): 138.

Kozloff, Max. "American Painting During the Cold War." *Artforum* 11, no. 9 (1973): 43–54.

Mellow, James. "Jerome Witkin." *New York Times,* Oct. 1, 1973.

Netsky, Ron. "Old-Fashioned Draftsmanship in Artist's Work." *Rochester Democrat & Chronicle,* Feb. 17, 1991, sec. 3D.

Palmer, Richard. "Small Town Big Enough." *Syracuse Herald American Stars Magazine,* May 15, 1983.

Piche, Thomas. "Witkin's Work Intimate, Invigorating, Intricate." *Syracuse Herald American Stars Magazine,* July 10, 1983.

Raynor, Vivien. "Art: Paintings at the French Gallery Reflect City Life." *New York Times,* Mar. 31, 1985.

Rodman, Seldon. *Conversations with Artists,* 91. New York: Capricorn 1961.

Rose, Barbara. *American Art Since 1900.* New York: Praeger, 1975.

Rosenberg, Harold. "The American Action Painters." *ARTnews* 51, no. 5 (1952): 37.

Rubenstein, Betty Rogers. " . . . And Then There Was the Truth: Introducing the Paintings of Jerome Witkin." Lecture at conference of the Council for the World's Religions, Kiamesha Lake, N.Y., Sept. 17–22, 1987.

Speer, Virginia. *Moral Visions: Jerome Witkin.* Exhibition catalogue. Richmond, Va.: Marsh Gallery of the University of Richmond, 1986.

Steiner, George. "Master Class," *New Yorker,* May 30, 1988, 99.

Ward, John L. *American Realist Painting, 1945–1980.* Ann Arbor: UMI Research Press, 1989.

Wechsler, Jeffrey. *Realism and Realities: The Other Side of American Painting, 1940–1960.* Exhibition catalogue, New Brunswick, N.J.: Zimmerli Art Gallery, Rutgers University, 1981.

Witkin, Jerome. "A Painting in Progress." *Syracuse Scholar* 1, no. 1 (Winter 1979–80): 43–58.

Wolff, Theodore F. "Jewish Images of the '70s in American Art: Lively and Sophisticated." *Christian Science Monitor,* June 21, 1982.

———. "Jerome Witkin's Fine Show." *Christian Science Monitor,* Mar. 22, 1983.

———. "Psychologically Charged." *Christian Science Monitor,* Mar. 4, 1985.

———. "Pictorial Mythology: The New Paintings of Jerome Witkin." *Arts* 60, no. 3 (1985): 67.